CHURCHES OF EDINBURGH

BRIAN KING

AMBERLEY

This edition first published 2023

Amberley Publishing
The Hill, Stroud
Gloucestershire GL5 4EP

www.amberley-books.com

British Library Cataloguing in Publication Data.
A catalogue record for this book is available from the British Library.

ISBN 978 1 3981 1295 7 (print)
ISBN 978 1 3981 1296 4 (ebook)

Typesetting by SJmagic DESIGN SERVICES, India.
Printed in Great Britain.

CONTENTS

Map 4
Introduction 6

1. Augustine United Church 7
2. Barclay Viewforth Church 8
3. Broughton St Mary's Church 9
4. Canongate Kirk 11
5. Chalmers Church 14
6. Charlotte Chapel 16
7. Christ Church 17
8. Colinton Parish Church 18
9. Corstorphine Old Parish Church 20
10. Cramond Kirk 23
11. Duddingston Kirk 26
12. Eric Liddell Centre 29
13. Greenside Parish Church 30
14. Greyfriars Kirk 31
15. Holyrood Abbey 35
16. The Hub (former Tolbooth Kirk) 36
17. Liberton Kirk 38
18. Magdalen Chapel 39
19. Mansfield Traquair Centre 41
20. Morningside Parish Church 42
21. Morningside United Church 43
22. North Leith Parish Church 44
23. Old St Paul's 46
24. Palmerston Place Church 48
25. Polwarth Parish Church 49
26. Priestfield Parish Church 51
27. Sacred Heart 52
28. Chapel of St Albert the Great 55
29. St Andrew's and St George's West 57
30. St Anthony's Chapel 59
31. St Columba's Free Church 60
32. St Columba's by the Castle 61
33. The Parish Church of St Cuthbert 63
34. St Giles' Cathedral or the High Kirk of Edinburgh 66
35. St John's Episcopal Church 69
36. St Margaret's Chapel 72
37. St Margaret's Parish Church 74
38. St Mary's Episcopal Cathedral 75
39. St Mary's Catholic Cathedral 78
40. St Mary's Star of the Sea 80
41. St Michael and All Saints 82
42. St Patrick's 84
43. St Paul's and St George's 86
44. St Peter's 87
45. South Leith Parish Church 89
46. Trinity Apse 91
47. Tron Kirk 93

Select Bibliography 95
Acknowledgements 96

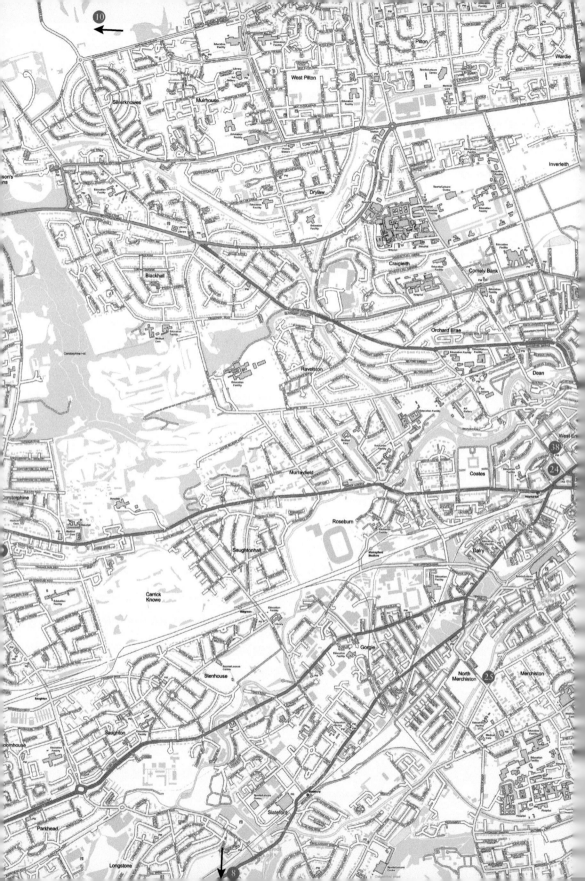

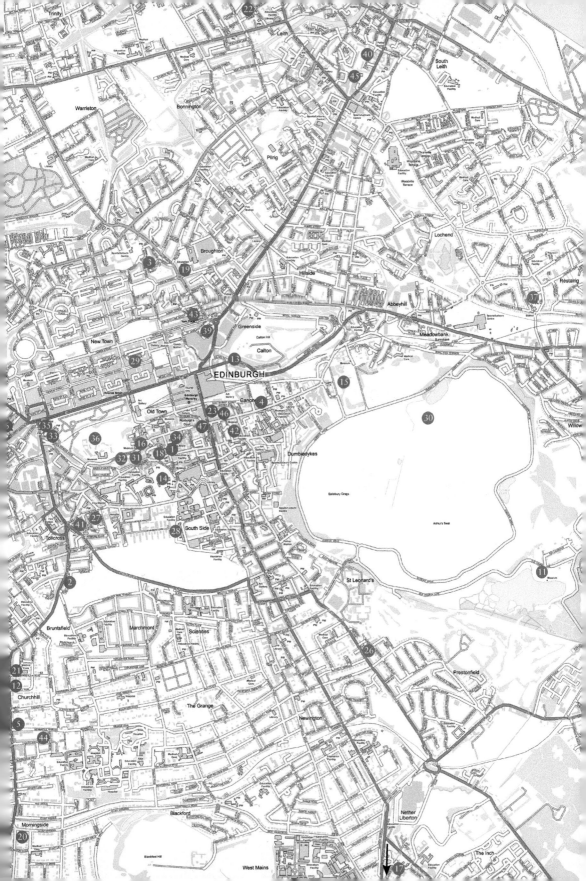

INTRODUCTION

'Edinburgh is a city of churches, as though it were a place of pilgrimage,' wrote one of the city's most famous sons, the novelist Robert Louis Stevenson. So integral a part of the fabric of Scotland's capital are its many churches that it is easy to pass by without giving them a second look, but whether you are a pilgrim, a tourist or merely a curious local there is much to learn from Edinburgh's churches.

In an increasingly secular age, many people are not as routinely exposed to churches as they might have been in the past. Weddings and funerals, which might have once guaranteed that even the most reluctant would occasionally visit a church, are now often held at other venues. This book aims to encourage people, including those with no religious faith, simply to stop and take that second look at the various churches of Edinburgh.

Of course, many who pick up a book such as this one will be people of faith. It is hoped that those visiting Edinburgh will find this a useful introduction to the city's churches and that even the most fervent church-attending Edinburgh resident will find something of interest about churches other than the one they are most familiar with or ones that are outwith their own denomination.

It is not really possible to understand the history of Edinburgh, or indeed Scotland as a whole, without acknowledging the role that religion and churches have played. The city's oldest surviving building is a chapel, thought to have been built by King David I in honour of his mother, Queen Margaret. Across the centuries, some of Edinburgh's churches have found themselves caught up in the events of history while others have had central roles to play in ecclesiastical events which themselves became important parts of Scottish history such as the Reformation or the National Covenant.

Many of Edinburgh's churches are interesting for their architecture. Some reflect the style of the time in which they were built while others are a hotchpotch of different influences mapping the alterations across years or even centuries. Others are home to fine artworks and furnishings such as stained-glass windows and offer the visitor a chance to see these items in the situation and fulfilling the purpose for which they were intended. Many churches are open to visitors on a regular basis and most can be accessed by arrangement. All currently active churches will, of course, welcome visitors to their regular services.

By no means all of Edinburgh's churches are included in this book, merely a selection of those that might be of interest to visitors. There are many fine and interesting churches which are not included, their omission is only due to

restrictions on space and the need to do justice to those which are featured. Readers are encouraged to seek out these other churches.

The book concentrates mainly on the city centre, with only a few trips out to the suburbs. A few former churches are included, too, to reflect their historic role in the city. In these cases, though, there is still something for a visitor to see. This book is being written at a time of upheaval for Church of Scotland churches in particular with many facing closure and it is even possible that some of the active churches featured will have closed by the time of publication. The situation has led to an initiative by the Scottish Churches Trust working with Historic Environment Scotland whereby volunteers document the contents of churches so that this information can be saved for future generations.

The churches are arranged by their current names in alphabetical order for ease of access and there is a map to show their locations

1. AUGUSTINE UNITED CHURCH, 11 GEORGE IV BRIDGE, EH1 1EL

The present Augustine United Church is the successor of a Congregational Chapel in North College Street which opened in 1802. That building was demolished to make way for what is now the National Museum of Scotland.

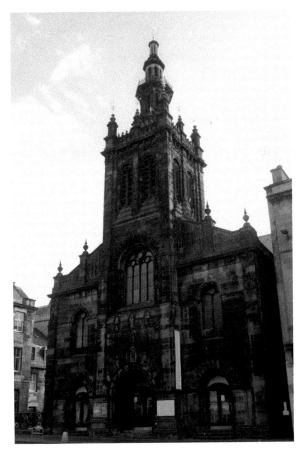

Augustine United Church – said to resemble a 'bridescake'.

The church on George IV Bridge was built between 1857 and 1861. The building is bigger than it may appear from the bridge as it also extends downwards to Merchant Street.

The design was by Hays of Liverpool and incorporated a variety of influences including Romanesque and Renaissance. Professor John Stuart Blackie famously compared the tiered building to a 'bridescake', though his friend the then minister Reverend Lindsay Alexander countered that it had met with the approval of the Chancellor of the Exchequer, William Gladstone, who visited the church shortly after its opening. Reverend Alexander is still remembered today in two colourful stained-glass windows dating from 1903 which were presented to the church by his son and are the work of the designer Robert Burns. These are currently to be found in the main sanctuary of the church.

There have been many changes to the interior over the years, most notably in 1968 to create office space under the galleries and in the early 1990s when the old pulpit and pews were removed to allow for greater flexibility of use. As well as being an active place of worship, the building is now suitable for a variety of purposes and among many other things is the home of Christian Aid in Scotland.

In 2002, there was a major renovation and reconstruction of the spire, which had been partially dismantled twenty years earlier after becoming unstable. The entire roof was replaced in 2016. The result of several unions, Augustine is today part of the United Reformed Church and is also part of a local ecumenical partnership with St Columba's by the Castle and Greyfriars Kirk.

2. BARCLAY VIEWFORTH CHURCH, 1 WRIGHT'S HOUSES, EH10 4HN

Originally named Barclay Church, after Miss Mary Barclay whose legacy financed its construction as a Free Church between 1862 and 1863, Barclay Viewforth Church is a unique building, which today houses a Church of Scotland congregation. The design was the result of a competition won by Frederick Pilkington and it seems unlikely that any other architect would have attempted what he did. Faced with the limitations of the size of the site, Pilkington seems to have bypassed them by heading upwards, producing a strikingly tall building with steep roofs and a 250-foot (76 metres) spire which pierces the sky over Bruntsfield Links.

The height allowed him to produce an interior which was more akin to a theatrical design than a traditional church, with two tiers of galleries and a painted ceiling. This suited the Free Church style of worship which was focused on the pulpit. The organ, by the Hope-Jones Electric Organ Company with a case by Sydney Mitchell, was not installed until 1898. Mitchell was also responsible for the adjoining halls, built in 1892, and which do a good job of blending in with Pilkington's unique style.

An unusual feature of the church is the Pillar Hall – so called because it contains the pillars which support the first balcony. Originally used for a Sunday school, the glass partitions dividing it from the main part of the church could slide down to enable direct sight of the pulpit when required. Beside the Pillar Hall is the

Barclay Viewforth Church from Bruntsfield Links.

vestibule which contains a bust of James Hood Wilson, the first minister of the church, and, in a glass case, a 'Vinegar Bible' – so called because of the misprint referring to the Parable of the Vineyard as the Parable of the Vinegar.

3. BROUGHTON ST MARY'S CHURCH, 12 BELLEVUE CRESCENT, EH3 6NE

Broughton St Mary's, originally known as Bellevue Church and later St Mary's Parish Church, is a distinctive landmark of the eastern part of Edinburgh's New Town. It opened for public worship on 12 December 1824, having been designed by the City Superintendent of Works, Thomas Brown, to form the centrepiece of the new Bellevue Crescent. It would be a further two years, though, before the spire was completed and the clock installed. Few today would be likely to find this imposing neoclassical building anything less than impressive but a writer in *The Scotsman* at the time of its opening did not share this opinion, saying that 'it is a decent, orderly, old-fashioned, poor sort of indifferent thing'.

Perhaps the most striking feature of the church's interior is the unusually high pulpit, which is said to have been based on the monument to Lysicrates at Athens. This was also the model for the monuments to Dugald Stewart and Robert Burns on Calton Hill. There are also some fine stained-glass windows including

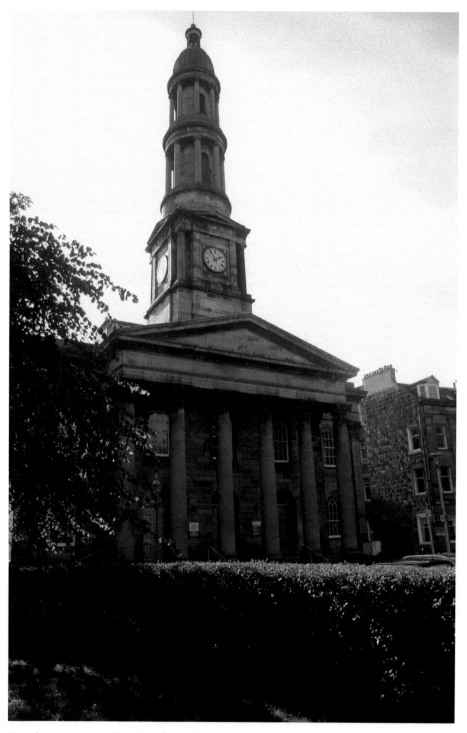

Broughton St Mary's Church, still standing despite a Zeppelin raid.

particularly notable depictions of the Adoration of the Magi and the Annunciation by Nathaniel Bryson.

Bryson had his workshop at Greenside, not far from the church. An earlier resident of that area was the civil engineer and pioneering lighthouse builder Robert Stevenson who lived in Baxter's Place. Stevenson, who was the grandfather of the novelist Robert Louis Stevenson, was an elder at the then St Mary's between 1828 and 1843.

The church gained its present name following a union with Broughton McDonald Church in 1992. More recent years have seen improvements made to the building including the extension of a staircase to the lower level which has now been opened up to provide facilities, including a kitchen and a bright garden room to the rear.

It is perhaps fortunate the church still exists at all. On the night of 2 April 1916, shortly before midnight, a Zeppelin dropped a high-explosive bomb which landed on a vacant patch of ground in Bellevue Terrace. Seven windows in the church were smashed, though no one was injured. Not everywhere in Edinburgh and Leith was so lucky on the night of the Zeppelin raid, which left thirteen people dead and twenty-four injured.

4. CANONGATE KIRK, 153 CANONGATE, EH8 8BN

In 1687, King James VII ordered that Holyrood Abbey be converted into a chapel for the Order of the Thistle and that a new church be built to serve the congregation of the Burgh of the Canongate which had previously worshipped at the Abbey. The funds were to come from money left by Thomas Moodie in 1649 which had originally been intended to pay for the erection of a church in the Grassmarket. The style of the resulting building, with its cruciform plan, is said to be unique among Scottish churches of the period and it has been speculated that it might have been built with possible conversion to Roman Catholic worship in mind. By the time the church opened in 1691, however, the Catholic King James had been replaced with William and Mary and a Protestant settlement was firmly in place in Scotland.

The distinctive Dutch-style front gable of the Canongate Kirk has a Roman Doric portico over the doors. Above this is an inscription recalling the church's origins, with the arms of Thomas Moodie above. Near the top are the arms of King William III and on the apex are a pair of antlers with a cross in the middle. This represents the arms of the Burgh of the Canongate. The antlers come from the King's private estate at Balmoral and are symbolic of an ongoing relationship with the royal family who attend regularly when resident at Holyrood Palace. There is a Royal Pew at the front of the church which has a model of the honours of Scotland on it.

Entering the church, the colour of the pews is probably the first thing to strike the visitor. Since 1950 they have been painted a light blue colour. This, together with the white walls, gives a light and airy atmosphere to the whole church. It was not always this way, however; the 1950 renovation also removed galleries and a partition wall, installed in the nineteenth century, which had completely obscured the apse.

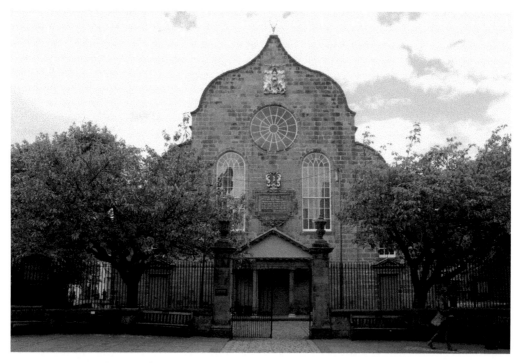

Canongate Kirk, opened in 1691.

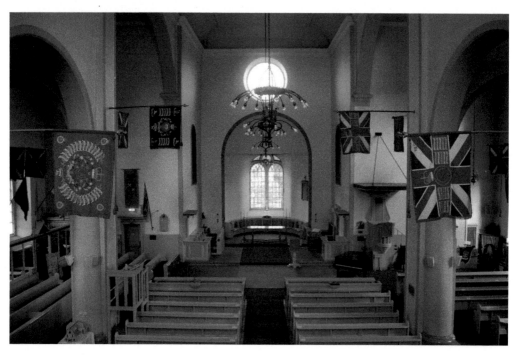

Interior of Canongate Kirk.

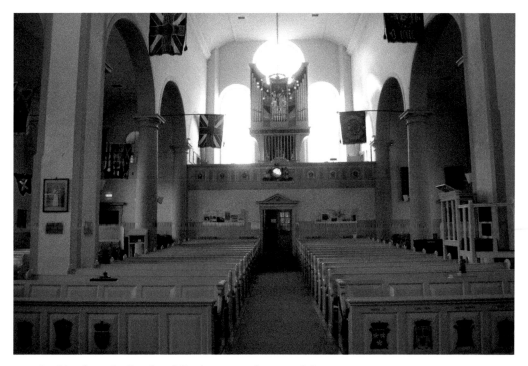

Looking from the Royal and Castle pews to the organ loft.

Also prominent are the military Colours of the Royal Scots (The Royal Regiment) and the King's Own Scottish Borderers. The kirk is now the Regimental Kirk of The Royal Regiment of Scotland. The War Memorial Chapel on the west side contains memorials to local men who died in the Second World War, veterans of Dunkirk and a Roll of Honour of 603 City of Edinburgh Squadron RAF. There is a further military connection as the church is also the local parish for Edinburgh Castle. On the opposite side from the Royal Pew is the Castle Pew, which has on its front the arms of various office holders including the Governor of the Castle.

Churches of whatever style are designed to draw the eye to the front but it is often rewarding to pay attention on the way out. Canongate Kirk is a great example of this. On the front of the gallery are the badges of some of the old Canongate trade guilds – cordiners, wrights, hammermen, tailors, baxters (or bakers) and weavers. In the centre of these is a clock which dates from 1817 and is said to have come from Holyrood Palace. The magnificent organ was installed in 1998 and was specially designed to fit its setting between the windows.

The kirkyard contains the remains of several notable people including Adam Smith, the economist and author of *The Wealth of Nations*, the philosopher Dugald Stewart and the artists John and Alexander Runciman. The poet Robert Fergusson is also buried there. He was a favourite of Robert Burns, who never met him but who paid for his gravestone. A statue of Fergusson stands outside the church gates. Of less certain provenance is the grave attributed to David Rizzio, the murdered secretary of Mary, Queen of Scots. Above the grave is a sign which

reads: 'Tradition says that this is the grave of David Riccio 1533-1566 Transported from Holyrood.'

Many have cast doubt on this, however, asking why the Catholic Rizzio would be reburied in a Protestant graveyard more than a century after his death.

5. CHALMERS CHURCH, 69B MORNINGSIDE ROAD, EH10 4AZ

In the early twelfth century, King David I gifted to the Burgh of Edinburgh a large area of ground which was to become known as the Burgh Muir. The village of Morningside grew up on part of this land. In the eighteenth century the village consisted of only a few houses but rapid expansion in the early years of the nineteenth century saw demand begin to grow for a church in the area.

In 1823, a schoolhouse was opened in the village and this was also used for religious services, but it was not until fifteen years later that the newly created Parish of Morningside gained its own church building on a site at the end of Newbattle Terrace. The preacher on the opening day was Dr Thomas Chalmers, who later became the Moderator of the first Assembly of the Free Church of Scotland.

Morningside Parish Church went on to serve the area for more than 150 years. In 1868, John Henderson's initial design was amended to include transepts and in 1888 the original apse was removed and replaced with a square chancel which would accommodate the organ and allow for more seating in the church. Over the years, several stained-glass panels depicting Bible stories were added and, like so

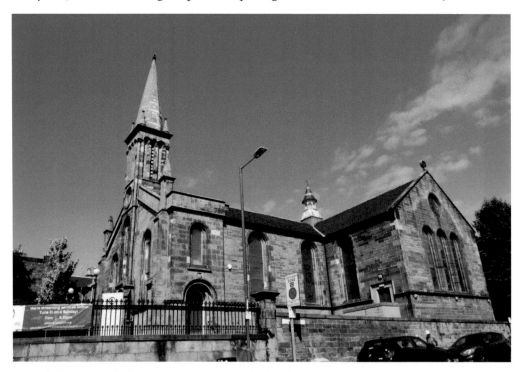

Chalmers Church (former Morningside Parish Church).

many of the other churches in this book, Morningside Parish Church gained war memorials with the names of the local dead.

Of note on the boundary wall outside the church is a lump of stone known as the Bore Stone. A plaque on the wall proclaims that this was the stone 'in which the Royal Standard was last pitched for the muster of the Scottish army on the Borough Muir before the Battle of Flodden 1513'. The plaque goes on to describe how it 'long lay in the adjoining field, was then built into the wall near this spot and finally placed here by Sir John Stuart Forbes of Pitsligo Bart. 1852'. There appears, however, to be a lack of corroborating historical evidence for this story.

In 1990, there was a union between Morningside and Braid churches which left the original Morningside Parish Church redundant. It came into the ownership of Napier University and it seemed unlikely that the building would ever be used as a place of worship again. In December 2016, though, it was sold to Chalmers Church and once again became home to a congregation. In the following years an ambitious renovation plan was put into effect to make Chalmers a modern place of worship and a centre for the local community.

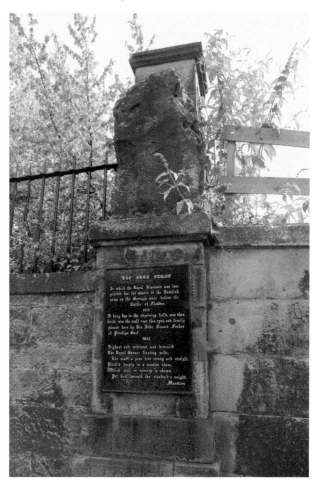

The Bore Stone which is reputed to have held the Royal Standard before the Battle of Flodden.

It is not only Morningside's earliest church that has been returned to use as a place of worship. In 2013, the Old Schoolhouse in which services were held prior to the building of the church came into the ownership of Cornerstone, an initiative of the Free Church of Scotland. The building was extended and renovated in 2020–21 to provide a suitable home for the congregation and a modern facility for the wider Morningside community.

6. CHARLOTTE CHAPEL, 58 SHANDWICK PLACE, EH2 4RT

The most distinctive feature of this church at the corner of Shandwick Place and Stafford Street is its 56-metre-high campanile or bell tower, which was designed by Robert Rowand Anderson and based on that of the church of St Giorgio Maggiore in Venice. This was not added until 1878–91, though, while the church itself had been built in 1866–69 and was designed by David Bryce. It was intended to house a Free Church congregation which had split from St George's Church in Charlotte Square in 1843. That congregation had initially moved to a new church at Lothian Road. When the railway was expanded, however, the Lothian Road church was dismantled and rebuilt in Deanhaugh Street (with the addition of a tower) as Stockbridge Free Church. Today only the tower survives there, incorporated into a housing development.

The Shandwick Place congregation, meanwhile, came back in to the Church of Scotland with the union of 1929 and became known as St George's West. In 2010, the congregation united with that of St Andrew's in George Street, leaving the

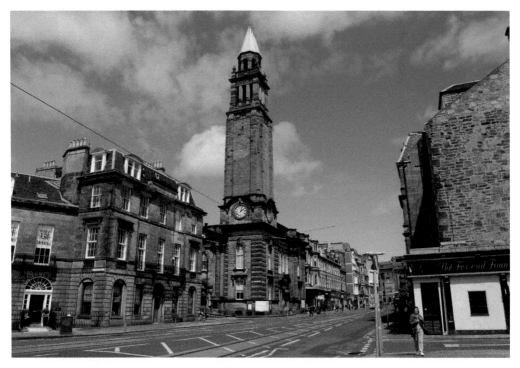

Charlotte Chapel (formerly St George's (West)).

Shandwick Place church vacant. It later became home to a Baptist congregation with a long and interesting history of its own.

Charlotte Chapel was founded in 1808 by an Edinburgh businessman named Christopher Anderson who had initially held meetings in the Pleasance area before moving in 1816 to a chapel in Rose Street. It was named Charlotte Chapel after the nearby square which, in turn, was named after King George III's Queen. This original Rose Street building was replaced by a larger one almost a century later in 1912 and the move to the church at Shandwick Place took place just over a century after that.

7. CHRIST CHURCH, 6A MORNINGSIDE ROAD, EH10 4DD

There were two opening ceremonies for Christ Church, Morningside's Episcopal church. The first took place on 5 June 1876 after the nave and transepts were built, the second on 12 March 1878 following the completion of the chancel, tower and vestry. The architect was a local man of French descent, Hippolyte Jean Blanc. He was also a member of the new congregation which had been meeting

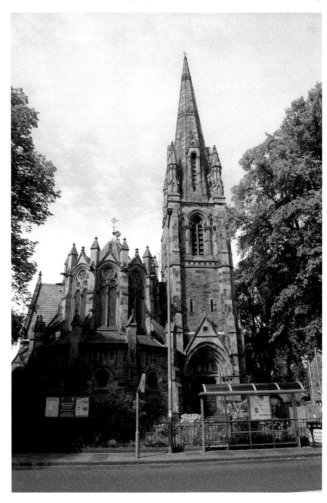

Christ Church, Morningside, part of 'Holy Corner'.

in the hall of Merchiston Castle since August 1874. He was still employed full-time at the Office of Works when he won the competition to build the church and worked on the project at home. Christ Church was Blanc's first ecclesiastical building but he would go on to be responsible for several others including its near neighbours St Matthew's Parish Church (now Morningside Parish Church) and Morningside Free Church (now the Church Hill Theatre) as well as the Thomas Coats Memorial Baptist Church in Paisley.

An abrupt slope on the ground presented a potential problem to Blanc but he turned this to his advantage with the construction of a hall beneath the church. The church itself is in a French Gothic style and follows a cruciform plan, though this is slightly obscured by the addition of the tower. The £3,000 cost of building the chancel was met by Miss Falconar of Falcon Hall and it was dedicated to the memory of her father, Alexander Falconar. Falcon Hall was situated between Newbattle Terrace and Canaan Lane and is remembered today in street names in that area.

The five-sided apse contains stained-glass windows by the Edinburgh firm Messrs James Ballantine and Son depicting scenes from the life of Christ. There are further stained-glass windows in the nave. The west rose window was added in 1926 to mark the church's fiftieth anniversary. The central panel shows Christ the Teacher with a child in his arms with cherubim occupying the surrounding panels. The design was by local artist Captain Alfred Edward Borthwick, who, like Hippolyte Blanc before him, was a member of the Christ Church congregation. The pulpit is a particular highlight of the church's interior. The design, by Blanc, with angels at each corner was realised by the local sculptor John Rhind. It has been fully restored in recent years. Indeed, the early years of the twenty-first century have seen a major renovation of the entire fabric of the church building.

8. COLINTON PARISH CHURCH, DELL ROAD, EH13 0JR
The history of Colinton Parish Church goes back far beyond that of the present building to when a church was founded on the site around 1095 by Prince Etheldred, son of King Malcolm III and Queen Margaret. This was replaced around 1650 and again in 1771. In 1837, David Bryce enlarged the church and added a bell tower. In 1907–8, the church was largely reconstructed by Sydney Mitchell, retaining the bell tower.

The neo-Byzantine-style interior has a semi-circular apse with nine small stained-glass windows in niches depicting the Christian virtues. There are also windows depicting King David and two pairs of angels under the west gallery and another in the organ loft depicting the words of Christ: 'Suffer the little children to come unto me' – a phrase repeated on the marble font.

There is much fine woodwork in the church, from the oak chancel screen which bears the motto 'O WORSHIP THE LORD IN THE BEAUTY OF HOLINESS' to the lectern, communion table and carved pulpit inscribed 'THE WORD OF GOD IS LIVING AND POWERFUL', which are also in oak. The war memorial is situated to right of chancel.

The kirkyard contains many interesting old graves including that of the artist Phoebe Anna Traquair with its self-designed gravestone (*see* entry for Mansfield

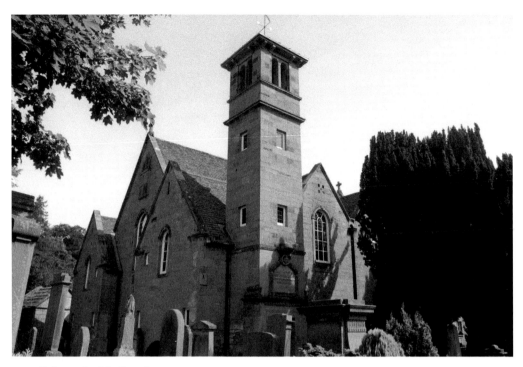

Colinton Parish Church.

Mort-safe in Colinton kirkyard.

Statue of the young Robert Louis Stevenson.

Traquair Centre). There is also an early nineteenth-century iron mort-safe which was used to protect newly buried bodies from 'Resurrectionists' or bodysnatchers, who would sell the bodies to the Edinburgh medical school.

Several buildings associated with the church from the eighteenth and early nineteenth centuries survive – namely the Offertory House, the old schoolhouse and the manse. The Offertory House was so called as collections for the poor, which were not allowed in the church, were gathered here. A frequent visitor to the manse in his younger days was Robert Louis Stevenson whose maternal grandfather, Dr Lewis Balfour, was minister at Colinton. A statue of the young Stevenson was unveiled in 2013. It is the work of Scottish sculptor Alan Herriot and stands in the small garden said to have inspired Stevenson's *A Child's Garden of Verses*. Also depicted is Stevenson's Skye terrier 'Cuillin' – surely the lesser-known of Edinburgh's two Skye terrier statues situated near a church.

9. Corstorphine Old Parish Church, 2a Corstorphine High Street, Corstorphine, EH12 7ST

This church can trace its history back to the second half of the fourteenth century when it was founded by Sir Adam Forrester, who was twice Provost of Edinburgh and who had acquired the lands of Corstorphine. It was built as a small chapel and situated next to the parish church of St Mary which had existed since at least 1128. Following Forrester's death in 1405, his family expanded the chapel and it

Corstorphine Old Parish Church.

became a collegiate church (a church where there was a 'college' or 'chapter' of priests presided over by a dean or provost) in 1429.

After the Reformation, the college was dissolved and parish worship was transferred from St Mary's to the former collegiate church building. St Mary's was demolished in around 1646 to allow for the addition of a north aisle to what was now the parish church. It is thought that the present entrance porch was built from some of the remnants of the old church. There were major restorations and additions to the church in 1828 by William Burn (which saw the disappearance of the 1646 north aisle) and in 1903–5 by George Henderson (which gave the nave its modern appearance). Despite many changes to the building, some parts such as the tower, south transept and chancel date from medieval times.

The tower was the scene of a notorious event that took place in 1649. Beatrix Watson, a local woman accused of witchcraft, hanged herself while kept imprisoned there. Her daughter Elizabeth and brother-in-law William were both executed in the witch-hunt that took place in Corstorphine that year. In 2021, a plaque was unveiled at the Corstorphine Heritage Centre (Dower House) in St Margaret's Park to remember those accused at that time.

There are many interesting features in the interior of the church. Heads based on those featured in Leonardo Da Vinci's *Last Supper* carved by Bernie Rhind adorn the corbels in the nave and date from the time of the 1905 restoration, as do most of the stained-glass windows. The exception to this is to be found in the baptistry where the large south window by Gordon Webster was installed in

View of the nave.

Looking towards the Baptistry and tomb of Sir Adam Forrester.

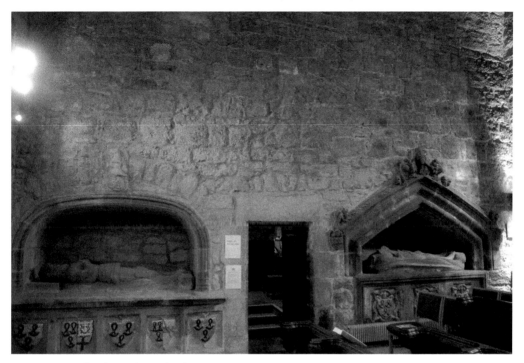

Forrester family tombs in the chancel.

1970. Beneath that window is a recessed tomb, traditionally thought to be that of Sir Adam Forrester. The medieval stone font came from the former Gogar Church which united with Corstorphine Old Parish Church. Nearby is the pulpit which is a based on that of the fourteenth-century theologian and biblical translator John Wycliffe, at Lutterworth in Leicestershire.

There is much evidence of the church's long history in the chancel and the sacristy (now the vestry). The west wall beside the priest's door has the commemorative dates 15429, 1455 and 1769. Beside the east window is the Sedilia where the pre-Reformation clergy would have sat during Mass. Here, as elsewhere in the church, there is evidence of damage thought to have been caused by Cromwell's troops in the seventeenth century. Also in the chancel are several memorial tablets including ones to Nicholas Bannatyne, the first Provost of the Collegiate Church in 1429, and George Henderson, the architect of the 1905 restoration. Flanking the vestry door are the tombs of Sir Adam Forrester's son, Sir John, who founded the collegiate church and that of his son, also Sir John. In the vestry itself, the medieval altar slab survives, as does evidence on the walls indicating the former position of the upper levels where the priests would have lived.

10. CRAMOND KIRK, CRAMOND GLEBE ROAD, CRAMOND, EH4 6NS

Cramond Kirk sits on the site of the principia of a Roman fort which was built around AD 142 and used as a base by the Emperor Septimus Severus in the early third century. It is said that the site has been used as a place of continuous

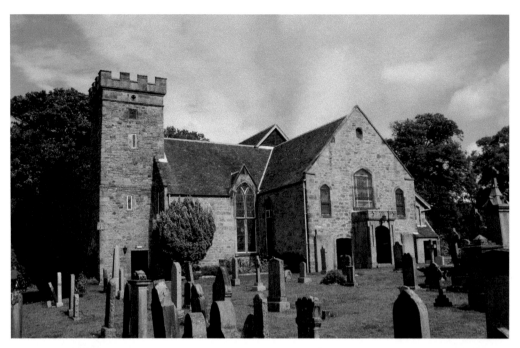

Cramond Kirk.

Interior view of Cramond Kirk from the north gallery.

Christian worship from the fifth century. The area was dedicated to St Columba and part of the Diocese of Dunkeld, whose bishop built nearby Cramond Tower as one of several residences.

The oldest surviving part of the church building is its tower, which dates from the fifteenth century albeit topped with a nineteenth-century parapet. The tower contains a Dutch bell cast in 1619 which was stolen in the 1650s by Cromwell's soldiers but later returned. It is still rung today.

The church was largely rebuilt in 1656 and much altered by later renovations, particularly that of 1911/12 which reorientated the church to a north/south axis from the traditional east/west layout and saw the addition of a north gallery. The galleries on the other three sides are named Barnton, Cramond and Dalmeny reflecting the names of the neighbouring estates whose owners and their households would traditionally have occupied them.

In September 1860, Queen Victoria visited Cramond House and attended a service at the kirk, sitting in the east or Cramond Gallery, where her chair remains to this day. At the start of the service, the church was said to be 'moderately well filled' but as word of the royal visitor spread, it became 'densely crowded' with people trying to get a glimpse of the Queen. Beneath this gallery is a smart, modern chapel which was installed in 2003 to provide a flexible space and allow for more intimate services.

Queen Victoria's chair in the Cramond Gallery.

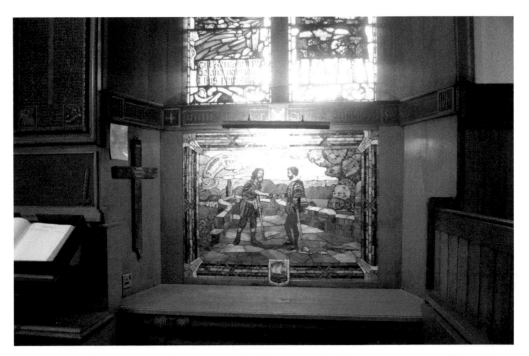

The Jock Howieson mosaic. The cross to the left once marked the temporary grave of Second Lt David Borthwick Tait who died in the First World War.

Below the north gallery are stained-glass windows depicting Saints Andrew, Cuthbert Columba and Margaret which were donated to the church in 1930, while on the east wall is a bust of Sir James Hope who died in 1661. On the west wall is a board listing the names of all the ministers since the Reformation. Among these is Robert Walker who, in 1788, encouraged the Presbytery of Edinburgh to petition Parliament to end the slave trade. He is more often remembered today, though, as the skating minister immortalised in Raeburn's painting of the same name.

The communion table is located underneath Barnton Gallery on the south. On one side of this is the war memorial and a mosaic depicting the story of Jock Howieson, a poor resident at Cramond Brig who came to the aid of a stranger being attacked by robbers only to find that he had rescued King James V. He was granted land by the king in gratitude. On the other side is the font and the pulpit which bears a dedication to the memory of Reverend James Alexander Milne who died in November 1909 at the age of thirty-nine. Earlier that month Milne had spoken at length about his hopes for the renovation of the building. Though he did not live to see the plans fulfilled, the church as we see it today largely reflects the vision he outlined.

11. Duddingston Kirk, 5 Old Church Lane, Duddingston, EH15 3PX

Many of what were once Edinburgh's surrounding villages have been entirely swallowed up by the city, but Duddingston's location in the shadow of Arthur's

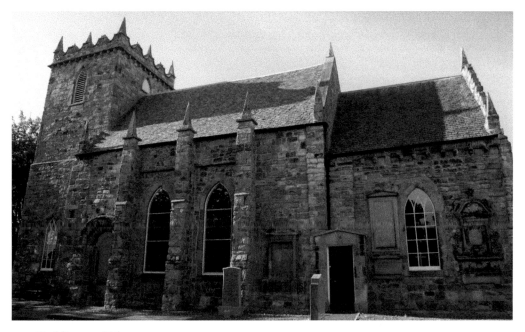

Duddingston Kirk.

Original doorway with Norman arch.

Seat and on the shores of the loch of the same name has ensured that it retains its rural feel and consequently, its church very much has the appearance of a village church. A study of the architecture reveals, too, that this is a very old church and, indeed, it is said to be one of the oldest still used for worship in Scotland.

It was built at some time in the early twelfth century and originally consisted of only the chancel and nave, which followed an east/west axis. The closed-up original doorway with its Norman arch is still visible on the south wall. The present entrance is to be found on the north side next to a war memorial listing the names of the parishioners who died in the First World War.

The building has undergone numerous changes over the years with the major structural alteration being the addition of the west tower and the north aisle. Alterations to the interior layout were also made in the nineteenth and twentieth centuries. One major interior feature, though, can be traced back to the earliest days of the church, namely the large Norman arch which separates the nave and chancel.

There are several interesting stained-glass windows. One, showing St Luke, is dedicated to the Reverend John Thomson, minister of the parish in the early nineteenth century and also a fine landscape painter. He was a friend of artists Turner and Raeburn and the novelist (and elder of Duddingston Kirk) Sir Walter Scott. Thomson is said to have been in the habit of referring to his congregation as 'ma bairns' giving rise, some say, to the expression 'Jock Tamson's bairns'. Another window is dedicated to Joan Carfrae Pinkerton who was born in Duddingston in 1822 and later married Allan Pinkerton, the founder of Pinkerton Detective Agency.

The jougs and the 'loupin-on stane'.

At the entrance to the kirkyard is a gatehouse which was used in the early nineteenth century to look out for bodysnatchers. Outside the gate are other remnants of times gone by in the shape of the jougs (iron collar and chain) which were used between the sixteenth and eighteenth centuries to shame people into repentance, and the 'loupin-on stane', which helped people attending the church to get on and off their horses.

12. ERIC LIDDELL CENTRE, 15 MORNINGSIDE ROAD, EH10 4DP

The Eric Liddell Centre is the result of a joint venture among four churches in the Morningside area in the late 1970s – namely Morningside Baptist Church, Christ Church, North Morningside Church and Morningside Congregational Church – who wished to establish a centre that would be 'an expression of their joint Christian witness to further the provision of community services'. When the imposing former North Morningside Church, dating from 1879, became redundant it was renovated and became the Eric Liddell Centre. Today it lives up to its original mission being used by numerous groups, charities and other bodies.

Eric Liddell was a Christian missionary, international rugby player and Olympic athlete. He was born in China in 1902 where both his Scottish parents were missionaries. He attended Edinburgh University and while living in the city became involved with the Morningside Congregational Church. Such were Liddell's religious convictions that he famously refused to run in the heats for the 100 metres at the 1924 Paris Olympics because they were held on a Sunday.

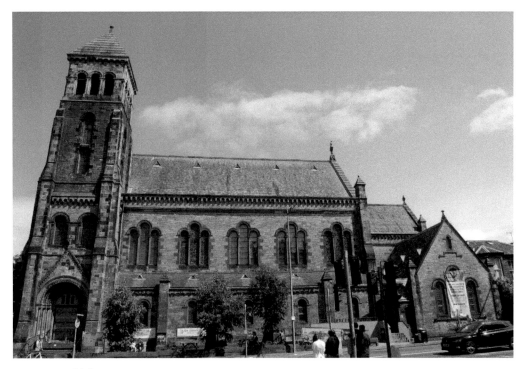

Eric Liddell Centre.

Instead, he competed in the 400 metres which was held on a weekday, an event that he won. The events were portrayed in the 1981 film *Chariots of Fire*. Liddell returned to China in 1925 to work as a missionary, returning to Scotland on only a couple of occasions. He died in a Japanese civilian internment camp in 1945.

The conversion of the North Morningside Church to the Eric Liddell Centre effectively involved constructing a four-storey office building within the nave of the original church. Added to this are cantilevered walkways which allow close-up views of the fine collection of stained-glass windows. The windows, which were renovated in the early twenty-first century, feature works by many significant artists, including William Wilson. One of Wilson's windows was actually constructed by his assistant John Blyth as Wilson was losing his eyesight at the time. Tours of all the various stained-glass windows can be arranged and the walkways mean that the visitor today is afforded a much better view than would ever have been possible to worshippers in the past.

13. GREENSIDE PARISH CHURCH, 1B ROYAL TERRACE, EH7 5AB

And at length, one melancholy afternoon in the early autumn … there came suddenly upon the face of all I saw - the long empty road, the lines of the tall houses, the church upon the hill, the woody hillside garden – a look of such a piercing sadness that my heart died; and seating myself on a door-step, I shed tears of miserable sympathy. A benevolent cat cumbered me the while with consolations -we two were alone in all that was visible of the London Road

Robert Louis Stevenson

Greenside Parish Church.

The 'church upon the hill' that the novelist Robert Louis Stevenson is recalling in this autobiographical passage is Greenside Church, the church where his grandfather Robert, the civil engineer and lighthouse builder, was an elder and which Stevenson himself attended as a child. Robert Stevenson's sons founded a chapel for the poor of the parish in their father's memory at Lower Greenside.

Christian worship on the 'green side' of Calton Hill dates back much longer than Stevenson's time, though, to the sixteenth century when the Carmelite or White Friars were granted land there to build a monastery. After the Reformation, the abandoned monastery buildings were used as a leper colony.

The present church opened in 1839 and it was, like its near neighbour St Mary's Catholic Cathedral, designed by James Gillespie Graham. It was built to a simple T-plan design with galleries in the transepts. A daughter church of St Cuthbert's, Greenside was intended to serve the growing population of William Henry Playfair's Calton scheme and provided a picturesque ending for Royal Terrace. The distinctive tower was part of Gillespie Graham's original design but not completed until 1852. The basement was used for a school but later became a meeting hall. In 1885, the church substantially was remodelled by David Robertson. The galleries were removed and a new one added with stair halls added to either side of the tower, completing the familiar silhouette of the church.

14. GREYFRIARS KIRK, 26A CANDLEMAKER ROW, EH1 2QQ

In the middle of the fourteenth century, long before the White Friars were established at Greenside, an area of ground bounded on the north by the present site of the Grassmarket and on the east by that of Candlemaker Row was granted to the Franciscans (or Grey Friars) to establish a friary in Edinburgh. The friary was abandoned at the time of the Reformation in 1560 and within a few years its buildings had been removed and their stones plundered. Mary, Queen of Scots later granted part of the grounds to the town council for use as a burial site.

In 1584, the council divided Edinburgh into four parishes. The south-west parish congregation met in part of St Giles' but soon required a church of its own. Work on Greyfriars, Edinburgh's first post-Reformation church, began in 1602, though it was not completed until 1620.

The years after the Reformation saw a conflict between the Presbyterian Church of Scotland and the Stuart kings as to who ultimately controlled the church. The reformers, though loyal to the king, could not accept the concept of the monarch's divine right to govern and in particular any claim that the monarch was the spiritual head of the Church of Scotland. In 1637, King Charles I introduced the Book of Common Prayer to Scotland and declared that opposition to the new liturgy would be treason. In 1638, the National Covenant was signed at Greyfriars. Copies were then distributed across Scotland. The Covenant committed the signatories to defend the nation's Presbyterian system of religion and oppose any changes. It is undoubtedly one of the most important documents in Scottish history and a copy is on display at Greyfriars.

In the 1650s church furnishings were damaged when Greyfriars was used as a barracks by Cromwell's troops. Worse was to come in the early eighteenth century, when the town council used the tower then situated at the west end of Greyfriars

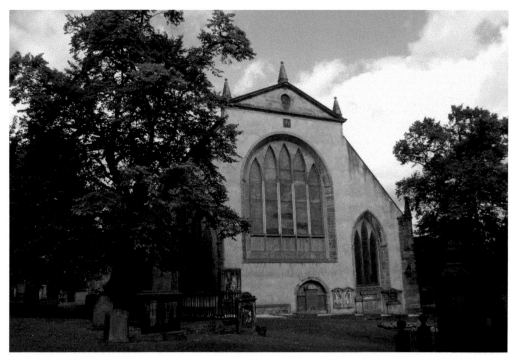

Greyfriars' Kirk.

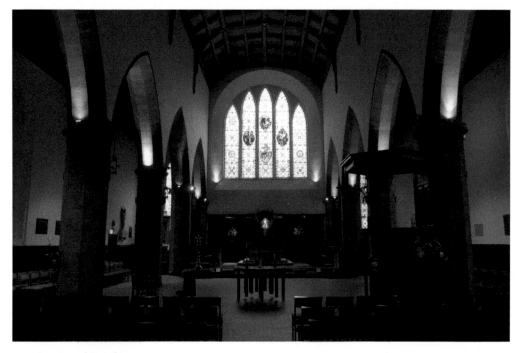

Interior of Greyfriars.

as a gunpowder store – with predictable consequences. In 1718, it exploded destroying the tower and damaging the church. When it was repaired, a second church, known as New Greyfriars and adjoining the old church, was added and a separate congregation was formed.

In January 1845, a fire devastated Old Greyfriars and damaged New Greyfriars. *The Scotsman* questioned whether either should be saved considering the number of churches that there were in the city by this time: '...it will not surely be proposed that both should be rebuilt. There is really no need for either of them.' The churches were repaired, though Old Greyfriars did not reopen for another twelve years. The minister, Reverend Robert Lee, took the opportunity to make some changes including the introduction of stained-glass windows. He later installed an organ. These were controversial changes in view of the preference for unadorned worship that then prevailed in the Church of Scotland and Lee was set to be tried for innovation by the General Assembly but died before this could take place. Within a few years, however, his ideas were widely adopted.

In 1929 there was a union between Old and New Greyfriars and in the 1930s the building was refurbished and the dividing wall between the churches removed, creating the building we know today. The Californian redwood ceiling was installed at this time. Elsewhere inside the church, there are monuments to Lady Yester (removed from the church bearing her name which amalgamated with Greyfriars) and to the once controversial minister, Robert Lee. At either end of the church are what are, in effect, monuments to the fact that his point of

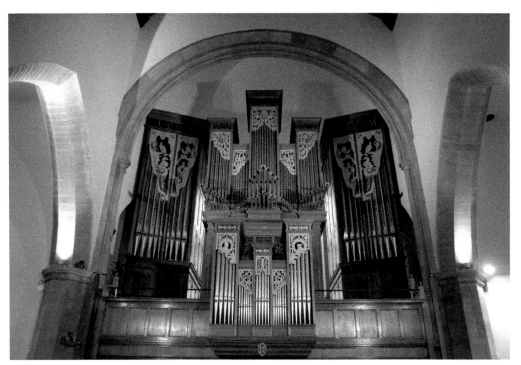

The organ at Greyfriars.

view eventually came to be accepted in the Church of Scotland. In the east, the stained-glass windows, which date from 1857, contain roundels depicting various parables. In the west stands a magnificent organ which was installed in 1990. The Latin motto on top of its pipe casings translates as 'Let everything that hath breath praise the Lord.'

Among the interesting features of the kirkyard are the Martyr's Monument, which commemorates executed Covenanters, and the mausoleum of their nemesis George Mackenzie, the Lord Advocate under Charles II. The Covenanters suffered persecution in the period following the Restoration of the monarchy. After the Battle of Bothwell Bridge in 1679 a large number were imprisoned in a field adjoining the kirkyard and partially enclosed by a section of the Flodden Wall, the city's sixteenth-century boundary. The area is still known as the Covenanters' Prison.

Also reputedly buried in the graveyard is William McGonagall, the notoriously bad poet, more closely associated with Dundee but who was born and died in Edinburgh. McGonagall is one of several names from the graveyard said to have inspired the author JK Rowling in writing the Harry Potter books.

No section on Greyfriars could pass without at least a brief mention of a certain Skye terrier. Greyfriars Bobby is famously said to have guarded the grave of his master, John Gray, for fourteen years after his death. His loyalty caught the public imagination and a statue was erected in 1872 at the corner of George IV Bridge and Candlemaker Row. There is also a memorial to Bobby just inside the entrance

Memorials to Greyfriars Bobby.

to the church grounds and John Gray's grave now has a memorial stone. There is a painting of Bobby dating from 1867 in the small museum at Greyfriars. It is not every place of worship in Edinburgh that has its own museum but it is perhaps fitting that there is one in this most historic of churches.

15. HOLYROOD ABBEY, CANONGATE, EH8 8DX

According to legend, King David I was hunting in what is now Holyrood Park when he was thrown from his horse after being startled by a stag. He was saved from being gored to death by the miraculous appearance of a holy cross (or holy rood). The grateful king founded an abbey on the spot in 1128. A fragment of the True Cross acquired by St Margaret and known as the Black Rood of Scotland was housed there, providing an alternative explanation for the name.

The abbey became a place of great importance in the religious and political life of Scotland. Several royal weddings and burials took place there. The Scottish parliament met at the abbey on various occasions from the thirteenth to the fifteenth centuries, not far from where the re-established Scottish parliament sits today. The abbey's guest house, which was situated to the west of the cloister, was often used as a royal residence. Between 1498 and 1501, the Palace of Holyroodhouse was built there.

The fabric of abbey itself suffered greatly in the sixteenth century, firstly in the 'Rough Wooing' by the invading English army and later in the Reformation. In 1570, the choir and transept were demolished, leaving only the nave. This was

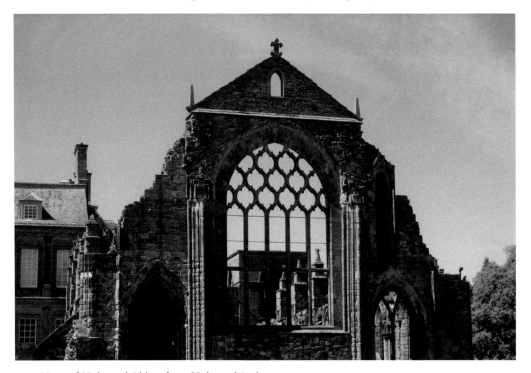

View of Holyrood Abbey from Holyrood Park.

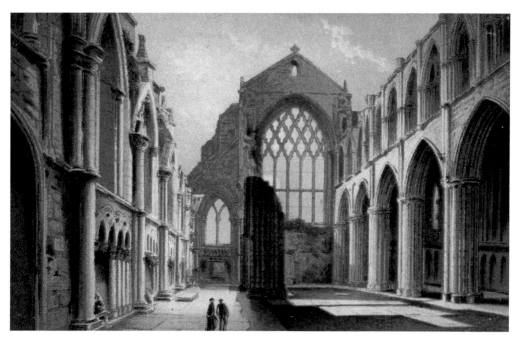

Old postcard view of Holyrood Abbey.

used as the parish church for the Burgh of the Canongate. In 1687, however, as we have seen, the congregation was moved to the new Canongate Kirk and the abbey converted into a chapel for the Order of the Thistle and Roman Catholic worship by King James VII. However, in December 1688, following James's removal, the church was destroyed by a Protestant mob.

The abbey's roof collapsed in 1768 following a disastrous renovation ten years earlier. The building has remained a ruin ever since though it has twice been proposed that it be restored either to provide a home for the General Assembly of the Church of Scotland or for the Order of the Thistle. Neither scheme was taken forward.

16. THE HUB (FORMER TOLBOOTH KIRK), CASTLEHILL, EH1 2NE

No longer used as a church, the former Tolbooth Kirk earns its place in this book by virtue of its prominent place both in Edinburgh's church history and the city's skyline. It was built to serve a dual purpose – to be a meeting place for the General Assembly of the Church of Scotland and a church for the Tollbooth congregation. Both functions had previously been undertaken by St Giles'.

The site at the foot of Castlehill had been earmarked as the site for a John Knox Memorial Church but this was never completed. The foundation stone for the new building was laid by Lord Frederick Fitzclarence, the Grand Master Mason of Scotland, on 3 September 1842. Queen Victoria, after whom the General Assembly Hall was to be named, was visiting Edinburgh Castle at the time but does not appear to have taken part in the ceremony. Instead, according to a

The Hub (former Tolbooth Kirk).

report in *The Witness*, she 'noticed, in an especial manner, the Grand Master by repeatedly bowing to him and waving her hand' as she passed by on her way to and from the castle.

The most striking feature of the Gothic design by Augustus Pugin and James Gillespie Graham is the 241-foot (73 metres) spire, which is the highest point in the Old Town and a prominent landmark. Internally, perhaps the most unusual feature is that the building is split over two storeys. The lower floor was divided into offices and committee rooms for the General Assembly. The upper floor was a single large chamber to be used for the meetings of the General Assembly or as a church. The Assembly went on to meet in the building until 1929, when the Church of Scotland reunited with the United Free Church and thereafter decided to use that church's Assembly Hall on The Mound. The building continued to be used as a church, being known latterly as the Highland Tollbooth St John's Church, until 1979 when it united with Greyfriars Kirk.

In 1999, the Tolbooth Kirk was reopened as The Hub, the home of the Edinburgh International Festival. It serves a variety of functions including being a ticket office, information centre and performance venue. The converted building was opened by Queen Elizabeth, who presumably took a more active role in proceedings than her great-great-grandmother did in 1842.

17. LIBERTON KIRK, 28-30 KIRKGATE, EH16 6RY

With its elevated location overlooking the city and its covering of Virginia creeper which changes with the seasons, Liberton Kirk is perhaps the most photogenic of

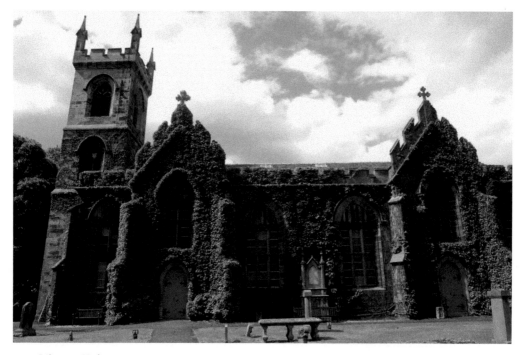

Liberton Kirk.

Edinburgh's churches. The present building dates from 1815 and was designed by James Gillespie Graham, replacing an earlier building.

The first documentary evidence for a place of worship at Liberton dates from 1143 when reference is made to a chapel there which belonged to the Parish of St Cuthbert, being granted by King David I to the Abbey of Holyrood. It became a parish church in its own right at the time of the Reformation. Christian worship appears to long predate even the earliest known building, though, as two Celtic crosses dating from between the eighth and eleventh centuries were discovered in the area. The design from one of these crosses is used in the church logo and features on the glass entry doors.

The interior of the church is orientated to face the pulpit and communion table on the south wall and is overlooked by a gallery on three sides. The building was altered in 1882, 1958 and 2007, and each time the seating capacity was reduced, though the church still seats more than 700. There are two war memorials in the church as well as a stained-glass window by Ballantine in memory of an elder of the kirk Major General Andrew Gilbert Wauchope who died in the Boer War.

Not everything of historic interest is contained in the main body of the kirk. There are several interesting framed documents on the wall in the vestry and the elders' room contains many memorials to members of the Baird family as well as a gallery of former ministers and a seventeenth-century pewter collection plate.

Outside the church, the kirkyard contains many interesting old gravestones. A more recent addition is the cairn which commemorates the bicentenary of the present building in 2015 and is dedicated to the 'living stones' – the people of the church past and present. The distinctive tower is accessed separately from the main church and contains a bell which dates from 1747 and is thus older than the present building.

The church gates and offering house were added in 1818. This also served as a watch house in grave-robbing times. In December 1827, the watchman caught a bodysnatcher attempting to open a grave and handed him over to the local sheriff. The following night, in the atmosphere of panic that followed this event, an innocent local man was shot in the graveyard when he was mistaken for a grave-robber.

18. MAGDALEN CHAPEL, 41 COWGATE, EH1 1JR

It is easy to miss the Magdalen Chapel, nestling in the sometimes gloomy Cowgate, but it is a place of great historical significance. It was built between 1541 and 1544 using a bequest from a local merchant, Michael MacQueen, and money raised by his widow, Janet Rynd, though the tower and steeple were not added until the 1620s. Janet Rynd died in 1553 and was buried in the chapel.

The building was used as a Guildhall and chapel for the Incorporation of Hammermen and also an almshouse for seven Bedesmen (poor men) 'who should continually pour forth prayers to Almighty God'. The prayers and the chaplain in this period were, of course, Roman Catholic but the Reformation was soon to occur and some believe that the first General Assembly of the Church of Scotland was held in the chapel in 1560. The General Assembly certainly did meet there in 1578. The Covenanters also met there in the following century and the bodies

The historic Magdalen Chapel
in the Cowgate.

of several of those who had died for the Covenanting cause were taken to the chapel to be prepared for burial. In 1689, the chapel was home to a particularly gruesome sight when the heads and hands of executed Covenanters, which had been publicly displayed, were gathered together there prior to interment in the nearby Greyfriars kirkyard.

In the eighteenth century, Magdalen Chapel was used by Episcopalians and Baptists and then in the early nineteenth century by a denomination known as the Bereans. It was later used for services by the Edinburgh Medical Missionary Society who had a dispensary next door. Their work is commemorated in several plaques in the chapel.

Of particular note on the inside of the building are the windows with stained-glass roundels depicting the Lion Rampant, the Arms of Mary of Guise, the Queen Regent and mother of Mary, Queen of Scots as well as the arms of the chapel's founders, Michael MacQueen and Janet Rynd. This is the only pre-Reformation stained-glass in Scotland that remains *in situ*.

There are many remnants of the centuries that the building was in the ownership of the Incorporation of Hammermen. There are inscribed panels on the

walls listing the names of the society's benefactors in gold letters. The Deacon's chair also remains in a prominent place today. Behind this is a semi-circular screen depicting eight shields representing the eight chief trades that were united in the Hammermen's Incorporation, and a central device showing the badge of the Hammermen themselves.

The chapel was fully renovated in 1993 and is currently the headquarters of the Scottish Reformation Society.

19. MANSFIELD TRAQUAIR CENTRE, 15 MANSFIELD PLACE, EH3 6BB

Now used as a venue for functions and office space for the Scottish Council for Voluntary Organisations, this former church was designed by Sir Robert Rowand Anderson and completed in 1885. It was built for the Catholic Apostolic Church, a denomination which had formed fifty years earlier. Their last priest in Edinburgh died in 1958 and the church was later used by the Reformed Baptist Church before worship at the site ceased altogether.

The building had fallen into disrepair over the years but was restored between 2002 and 2003. After this, the next two years were devoted to the restoration of the most interesting aspect of the interior – the murals by Phoebe Anna Traquair. Born Phoebe Anna Moss in Ireland in 1852, Traquair moved to Scotland in 1874, following her marriage to the Scottish palaeontologist Ramsay Traquair. She established herself as an artist in the Arts and Crafts style, working in a variety of forms.

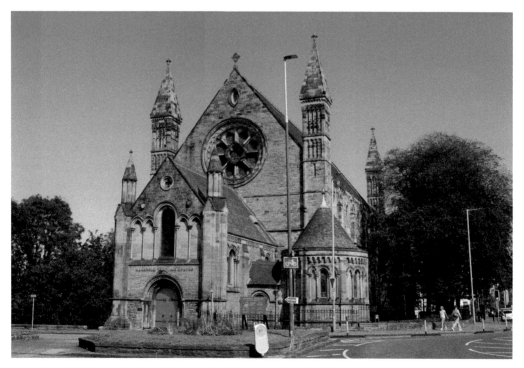

Mansfield Traquair Centre (former Catholic Apostolic Church).

Begun in 1892, the murals at the Catholic Apostolic Church were painted over several years and in a number of different styles. They depict various biblical scenes, including scenes from Life of Christ and various Old Testament scenes. The west wall shows the Second Coming of Christ. The building has regular open days as well as hosting functions, so the murals are accessible to the public.

20. MORNINGSIDE PARISH CHURCH, 2 CLUNY GARDENS, EH10 6BQ

In 1883, the then Morningside Parish Church established a mission station for the south Morningside area. The building in Cluny Avenue was a so-called Iron Kirk, a structure that came in kit form with corrugated iron being fixed onto a wooden frame. The church was given the name of St Matthew's. The congregation soon outgrew the Iron Kirk, which had had to be expanded on more than one occasion, and plans were put into place to erect a more permanent building. The foundation stone for this was laid on 1 June 1888 on a raised corner site at the junction of Cluny Gardens and Braid Road. The architect was Hippolyte Blanc who had designed the nearby Christ Church.

The red-sandstone Gothic-style building followed a cruciform design. The chancel was not added until 1901, though, when the organ by prominent maker Henry 'Father' Willis was also installed. Blanc's original plans also included a tower on the north-west side but this was never built. In 2010, an award-winning extension by local architects LDN helped to improve accessibility and provide a bright and airy flexible space to meet modern needs.

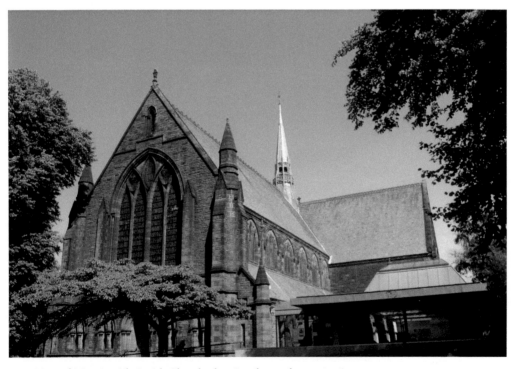

View of Morningside Parish Church, showing the modern extension.

St Matthew's Church became Cluny Parish Church in 1974 and Morningside Parish Church in 2003. The name changes were the results of various church unions. A stained-glass window to mark the 2003 union features an image of St Cuthbert's pectoral cross and crook in reference to the parish's ultimate mother church and a quote from Christ's Farewell Discourse in the Gospel of John: 'That they may all be one' to reflect the coming together of the Cluny Church with its near neighbour Morningside Braid. Indeed, the current Morningside Parish Church is ultimately a union of five former churches: St Matthew's (later Cluny Parish Church), the original Morningside Parish Church at Newbattle Terrace, Morningside High Church (now the Churchill Theatre), South Morningside Church (later the Cluny Centre) and Braid Church (now a pizza restaurant).

The then Cluny Parish Church briefly became the focus of the nation's attention in 1994 when the funeral of John Smith, the leader of the Labour Party and a regular member of the congregation, was held there. Smith had seemed poised to become Prime Minister at the next election and many view his sudden death as a major turning point in British political history.

21. MORNINGSIDE UNITED CHURCH, 15 CHAMBERLAIN ROAD, EH10 4DH

The first church to be constructed at what was to become known as Holy Corner was the Morningside United Presbyterian Church which occupied the site on the north side of Chamberlain Road. It opened in late 1863 and was constructed in

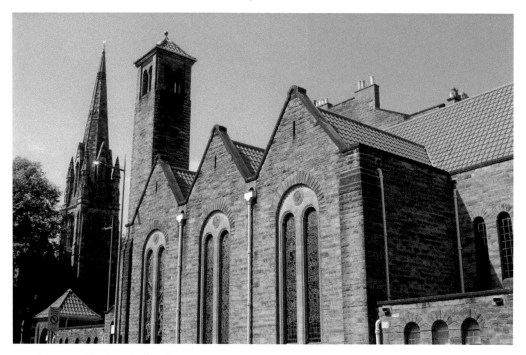

Morningside United Church.

the French Gothic style – not very well constructed, it appears, though, because less than five years later the front gable of the church collapsed during a storm, leaving the interior exposed. It was feared at the time that the entire roof would be blown off, but the building was secured and eventually repaired.

Over the years, the church became too small for the U. P. congregation and a new, much larger church (now the Eric Liddell Centre) was built across the road. The old church was sold in 1882 to a literary institute called the Morningside Athenaeum for use as a lecture hall and library. The seeds of a new church were soon planted in the lecture hall, though, when Morningside Congregational Church was established at a meeting there in 1887. By 1891, the trustees of the Congregational Church were in a position to buy the building from the Athenaeum Club.

Like their predecessors, the Congregationalists soon outgrew the building. The First Word War delayed rebuilding plans, however, and it was not until the second half of the 1920s that the present church was built to a design by James McLachlan. The extensive hall was built first and used for services until the church was ready.

The building has been described as art deco-Romanesque and notable features include the campanile, gabled side aisles and pavilions. On the west gable above the three arched windows and within a larger arched panel is a representation of a pelican. This has its origin in an old tradition whereby it was thought a pelican would pierce its own breast with its beak in order to feed its young with its own blood. It became a symbol of Christ's sacrifice for mankind and is often to be found in Christian art.

The interior is plain but bright and airy with the eye drawn to the plain wooden cross in the chancel with the pipes of the organ behind. There are three pairs of stained-glass windows on the south aisle, two of which serve as memorials to the First and Second World Wars and the third of which commemorates Eric Liddell, who as we have seen, attended the church.

The present Morningside United Church is the result of an inter-denominational union between Morningside Congregational Church (then part of the Scottish Congregational Union, later the United Reformed Church) and North Morningside Parish Church (Church of Scotland) which was the successor of the Morningside United Presbyterian Church.

22. NORTH LEITH PARISH CHURCH, 1A MADEIRA PLACE, EH6 4AW

This is another of the churches in Edinburgh which can trace its origins back to the Abbey of Holyrood. In 1493, the Abbot built a chapel dedicated to Saint Ninian on the north-west bank of the Water of Leith. Following the Reformation, the church was given to the local population but it proved to be too small and was demolished and rebuilt in 1586, becoming a parish in 1606. A Dutch-style tower was added to the building in 1675. This is still visible today in Quayside Street.

As the nineteenth century dawned, it soon became apparent that a bigger church was required for the expanding population of Leith. One day in April 1814, a procession which included everybody from local dignitaries to Newhaven fishermen left the old church and walked to a nearby field where the foundation

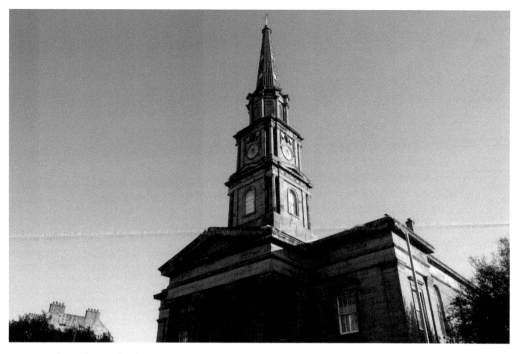

North Leith Parish Church.

Dutch-style tower of the original North Leith Parish Church in Quayside Street.

stone of a new church was laid. The neoclassical church was designed by Edinburgh architect William Burn and opened in 1816. Its setting soon became more urban as new streets were laid out and houses built in the vicinity.

In 1941, the church was declared to be unsafe after having been damaged by a landmine. Worship transferred to the church hall. It was not until 1950 that the church building was fully restored and refurbished and it could return to its intended purpose.

An unusual feature of the original interior was the pulpit, which was situated on the east wall. The minister was said to have stepped straight into the pulpit from the vestry, which was above the entrance vestibule. The pulpit was replaced in 1881 and again as part of the pre-1950 restoration. The current pulpit is entered in a more conventional manner from the floor of the church.

Next to the church is a modern church hall. Above its door is a burning bush image from the former St Ninian's Church in Ferry Road. This was the successor church of the Free Church congregation who had split from North Leith in 1843. The two congregations were reunited in 1982. North Leith had previously united with Bonnington Church in 1968.

23. OLD ST PAUL'S, 39 JEFFREY STREET, EH1 1DH

In 1689, when the Church of Scotland abolished the rule of bishops, Alexander Rose was forced to leave St Giles' Cathedral. Bishop Rose was followed by many of his congregation and they set up a new place of worship in an old wool store in nearby Carrubber's Close.

Life was not easy for the congregation of St Paul's (as the church was originally known) during the next century. They were outsiders in terms of the prevailing culture – Episcopalians and Jacobites in a Scotland that was Presbyterian and Hanoverian. Acceptance came only gradually as the Jacobite cause petered out after the death of Prince Charles Edward Stuart (Bonnie Prince Charlie) in 1788.

The 1867 Improvement Act saw the demolition of several buildings in Carrubber's Close and the building then housing the congregation was condemned. It closed in 1873 and was later demolished. A new church designed by William Hay and George Henderson was built on the same narrow and sloping site. It opened in 1883 and consisted only of the chancel and north part of the nave. The south part of the nave had been added by 1890. The rebuilt church was known as Old St Paul's to distinguish it from St Paul's (now St Paul's and St George's Church) in York Place.

The church today is entered via the Calvary Stair, a three-flight stone stair of thirty-three steps, one for each year of Christ's life and also representing the ascent to Calvary. There is a sculpture of the Crucifixion at the top as well as a memorial chapel. This part of the church dates from alterations in 1924–26. There is also an entrance in Carrubber's Close.

The stone-faced nave is particularly impressive and atmospheric, perhaps because it belies the apparently cramped nature of the exterior. A wrought-iron rood screen separates the nave from the chancel. There are paintings on either side of the chancel arch – a copy of the Immaculate Conception by Bartolome Esteban Murillo to the right and a tapestry picture of the Crucifixion by Cornelia Dick

Old St Paul's Episcopal Church.

Lauder on the left. There is a beautiful gilded triptych above the oak altar with a copy of Virgin and Child with Saints by Benvenuto di Giovanni in the centre. Higher still are three stained-glass windows depicting St Paul and St Columba with the Crucifixion in the centre.

There also four windows on the east side of the nave depicting Saints David, Margaret, Cuthbert and Giles and in the north-east corner of the nave is the wooden Children's Chapel, erected in 1929. The Lady Chapel (or Seabury Chapel) is named after Samuel Seabury, the first Bishop of the Episcopal Church in the United States who worshipped at the then St Paul's in 1752. A stained-glass window depicts his consecration as a bishop.

Behind the church are the Laurie Halls which house the vestries. The halls were built to replace a previous building on the site and in memory of Canon Albert Laurie who served Old St Paul's for forty-seven years. The Margaret Ann Lyall Memorial Garden is also situated behind the church. It was once home to the Oberammergau crucifix which now adorns the front of the building at Jeffrey Street – a public proclamation of the faith and style of worship of Old St Paul's that would have been unthinkable for that first congregation huddled in the wool store.

24. PALMERSTON PLACE CHURCH, 10 PALMERSTON PLACE, EH12 5AA

Palmerston Place Church was opened in 1875, having been designed by the architects Peddie and Kinnear. The Italianate frontage with its twin towers is believed to have been inspired by the seventeenth-century church of Saint-Sulpice in Paris. The interior, though, is much more austere, in keeping with the style of

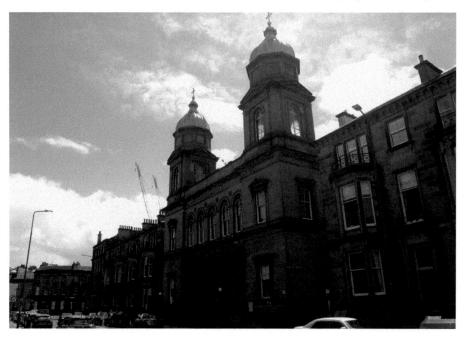

Palmerston Place Church.

worship of the United Presbyterian congregation for whom it was built. The UP congregation had, until then, met in Rose Street. Two collection plates from the Rose Street premises are still used in the church today.

Entering the church, it is the organ in the arch behind the pulpit that dominates the view. There has been an organ in the church since it was built. The original was installed at a cost of £400. This was a relatively new innovation for a United Presbyterian Church at the time. It was only in 1872 that the UP synod voted to allow their use in its churches, having previously argued that they took away from the simplicity of worship.

The main part of the church is D-shaped with fixed seating round three sides. The central section of wooden pews was removed in the 1990s to allow greater flexibility. There is a gallery above the fixed seating with granite arches that echo those on the outside of the building.

The United Presbyterian congregation that left Rose Street for Palmerston Place could trace its origin back through various denominations to the Church of Scotland and St Cuthbert's Parish Church. Following the major church unions of 1900 and 1929, the Palmerston Place congregation became a Church of Scotland one and in the 1970s was bolstered by unions with Belford Parish Church (now a hostel) and Lothian Road Parish Church (latterly the Filmhouse cinema).

25. POLWARTH PARISH CHURCH, 36-38 POLWARTH TERRACE, EH11 1LU

Polwarth Parish Church was built to a Gothic design by Sydney Mitchell and Wilson in several stages in the early years of the twentieth century. Originally a Free Church named after Robert Smith Candlish, one of the founding fathers

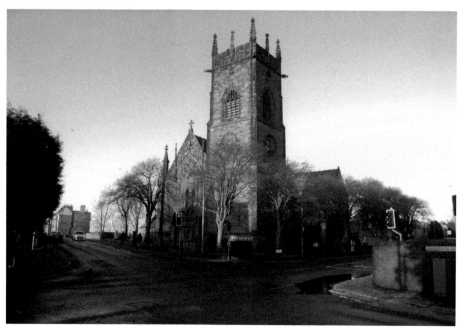

Polwarth Parish Church.

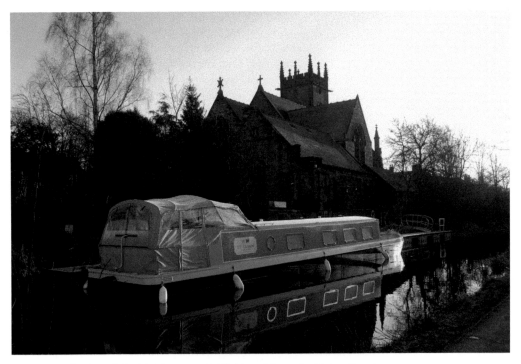

View of Polwarth Parish Church and *All Aboard* from the Union Canal.

of that denomination, the landmark red-sandstone building occupies a unique setting at the corner of Polwarth Terrace and Harrison Road and on the banks of the Union Canal. The present congregation is the result of a merger in 1981 with that of the now demolished John Ker Memorial Church in Polwarth Gardens.

Perhaps the most striking of the interior features are the large stained-glass window at the east of the church and the sandstone pulpit with marble insets sculpted by William Beveridge in 1903 which features statuettes of Dr Candlish and John Knox. The church also contains what at first appears to be a more modern and unique feature in the shape of the labyrinth which is stained onto the floor of the nave. The church's website, however, explains that it is 'a model of that path used through the ages as a tool for pilgrimage, meditation or prayer'. Indeed, labyrinths such as this one began appearing in European churches as far back as the twelfth century and there is a famous one at Chartres Cathedral.

Events using the labyrinth are held throughout the year and it also features on the church's logo alongside depictions of the church itself and the Union Canal. The canal is home to another of Polwarth Parish Church's distinctive features. In conjunction with the charity People Know How, the church operates a canal boat named *All Aboard*, which is moored on the canal and is suitable for a variety of purposes. The project aims to nurture community cohesion and well-being. The well-kept and tranquil church gardens, in their own way, serve a similar purpose.

26. Priestfield Parish Church, 2 Marchhall Place, EH16 5HW

This church was built as Rosehall United Presbyterian Church in 1877–79 to an Italian Lombardic design by James Sutherland and James Campbell Walker. The current parish is the result of a union with Prestonfield Church in 1974.

Of particular note are the stained-glass windows which were presented by Sir John Cowan in memory of his youngest son, Lt William Morison Cowan, who had died in 1919. They are the work of three different artists. Particularly unusual are the designs by Mary Wood which depict the trees and plants in the Bible. Other, more abstract windows on the ground floor are attributed to Douglas Hamilton though newspaper reports at the time of their dedication in 1922, list the artist as James Hamilton of Dundee. The remaining windows are by Alexander Strachan. These include the large windows behind the gallery which depict scenes of Christ with the leper and bearing his cross on either side of a scene from the Book of Revelation.

While all of the windows act as a war memorial, there is also a bronze plaque in the chancel dedicated to those who lost their lives in the First World War. The oak communion table comes from the old Prestonfield Church and is dedicated to the fallen of that parish. Particularly notable among the other furnishings is the font, which is in the shape of an angel holding a shell by John Rhind in the style of Danish neoclassical sculptor Bertel Thorvaldsen. Rhind produced another version of this design for St Giles' Cathedral.

Priestfield Parish Church.

27. SACRED HEART, 26 LAURISTON STREET, EH3 9DJ

The Society of Jesus (whose members are known as Jesuits) was founded by St Ignatius of Loyola in 1540 and was active in Scotland soon after that date. Some Jesuits continued to work in Scotland in the hostile climate of the post-Reformation period. Among these was St John Ogilvie who clandestinely ministered to Catholics in Edinburgh in 1614 before being arrested and executed in Glasgow the following year. It would have been unthinkable in Ogilvie's time that a Jesuit-run parish would one day be operating openly in Edinburgh. By the mid-nineteenth century, however, anti-Catholic laws had been relaxed and a Jesuit parish was founded in 1859, with the first Mass celebrated at a temporary premises at Hunter's Close in the Grassmarket on the Feast of St Ignatius, 31 July, that year.

The Catholic Church of the Sacred Heart of Jesus was opened in Lauriston Street a year later. A report in the Catholic newspaper the *Glasgow Free Press* said that 'the church makes no pretentions of architectural beauty. It is clearly built for hard work.' A modern visitor might agree that Jesuit architect Father Richard Vaughan's design is of a relatively simple shape and, indeed, it was built with possible conversion to a hall in mind. They would be unlikely, though, to agree with the newspaper's subsequent assertions that the interior furnishing was 'simple even to sternness' and that 'the eye is not diverted by any striking aesthetic beauties'. Entering the church today the eye is immediately drawn to the fourteen large paintings which comprise the Stations of the Cross. Depictions of these

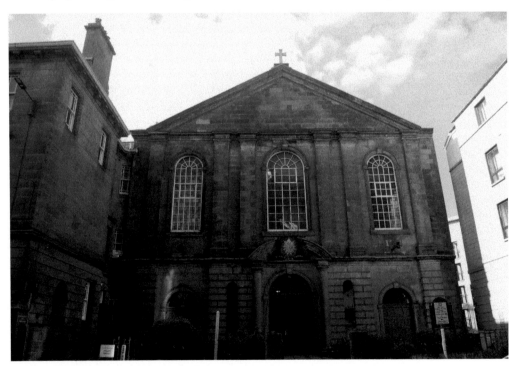

Catholic Church of the Sacred Heart of Jesus.

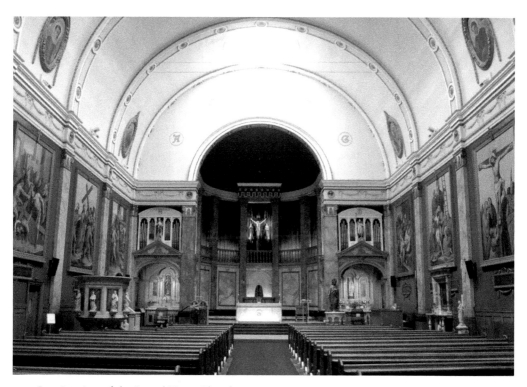

Interior view of the Sacred Heart Church.

stages in the journey of Christ to His Crucifixion and burial are commonly found in Catholic churches but rarely, in Scotland at least, on so impressive a scale. They were painted by Bavarian artist Peter Rauth between 1871 and 1874 and were restored between 1999 and 2002.

Were the *Free Press* reporter to visit the church today, they would also notice numerous other decorative additions such as the marble pulpit installed in 1895 and, indeed the entire chancel, designed by Archibald Macpherson which was built in 1884. They would see, too, the wooden carved Holyrood Madonna, gifted to the church within a few years of its opening and so called because it is reputed to have been in Holyrood Palace at one time. One thing they would not see, however, is the large mural of the Resurrection on the chancel arch commissioned in 1957 and painted by the artist Derek Clarke who was a lecturer at Edinburgh College of Art at the time. Clarke had included likenesses of members of his family, parishioners, Saint Ignatius, and Archbishop (and future Cardinal) Gordon Gray, all dressed in contemporary fashion. The mural was later papered over but remains in place should there ever be a desire uncover it.

Appropriately, there is a statue of St John Ogilvie in the church. Near to this is a small chapel dedicated to a much more recent martyr, St Oscar Romero, the Archbishop of San Salvador who was assassinated while celebrating Mass in 1980. He was canonised in 2018. A reliquary in the chapel contains part of the bloodstained alb he was wearing when he was shot.

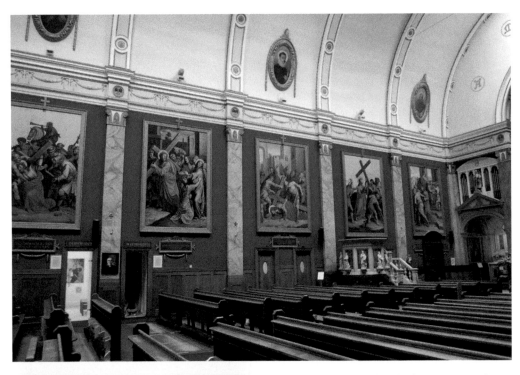

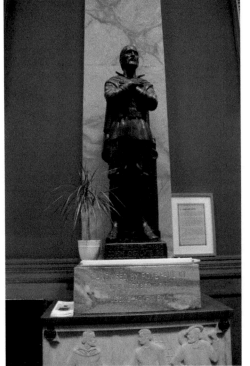

Above: View across the church showing some of the Stations of the Cross.

Left: Statue of St John Ogilvie.

In the early twentieth century, halls, again designed by Macpherson, were built adjoining the church and today these provide a base for the Edinburgh Jesuit Centre which offers courses, events and retreats in theology, spirituality, social justice and adult faith formation.

28. CHAPEL OF ST ALBERT THE GREAT, GEORGE SQUARE LANE, EH8 9LD

George Square in Edinburgh's South Side was laid out in 1766 by James Brown, who had purchased the ground five years earlier. Today the west is the only side whose Georgian appearance survives completely unaltered by twentieth-century brutalist additions. Nos 23 and 24 there were constructed in the early 1770s and now comprise St Albert's Catholic Chaplaincy which serves the University of Edinburgh, Edinburgh Napier University and Queen Margaret University.

In the nineteenth century, No. 23 George Square was subdivided and included medical student Arthur Conan Doyle as one of the residents of its upper floor, which was then known as No. 23B. It has been speculated that this might have been the origin of the 'B' in 221B Baker Street, the address of his most famous creation, Sherlock Holmes.

In December 1931, the Order of Preachers (known as the Dominicans, after their founder St Dominic) purchased No. 24 George Square for £2,400 and began their work among the students of the University of Edinburgh. That same month

Chapel of St Albert the Great.

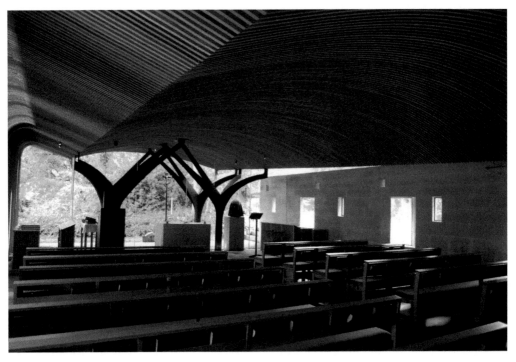

Interior of the chapel.

in Rome, a Dominican friar, bishop and philosopher named Albertus Magnus or Albert the Great, who had died in 1280, was canonised and declared a Doctor of the Church by Pope Pius XI. The George Square priory was dedicated to him in 1932. It was a fresh beginning for the Order in Edinburgh but actually only the latest chapter in a long history in the city.

The Order of Preachers was founded in early thirteenth-century France and was active in Scotland from 1230 when King Alexander II granted a charter giving the Dominicans a house and large piece of land on the south side of the Cowgate in Edinburgh, where they established a priory. They continued to carry out their work there for more than 300 years until the time of the Reformation. In 1559, the priory was sacked by a mob. No visible trace of the building remains today but a trance or lane that once marked the edge of the site survives under the name of High School Wynd. Across the Cowgate from this is the access to the High Street which acquired the name Blackfriars Wynd, later Blackfriars Street. (The Dominican friars were called Black Friars because of the black cloak worn over their white habits.) A plaque marking the site of the priory was unveiled in 2016.

In 1936, the Dominicans purchased 23 George Square and eventually acquired 23B in 1960. The upstairs drawing room of 24 George Square served as a chapel for many years but by the early twenty-first century was no longer considered suitable for the numbers attending or modern access requirements. It was decided to build a new chapel in the back garden of 23 and 24 George Square. Meanwhile,

No. 25 George Square, the childhood home of Sir Walter Scott, which had been purchased by the Order in 1969 and used mainly as a residence, was sold.

The new chapel opened in 2012. The design was by Simpson & Brown and makes full use of the garden setting and the approach from George Square Lane at the rear of the building. The glazed west wall behind the sanctuary connects the chapel directly to the outside environment. The curved, oak-lined timber roof is supported by four steel columns shaped like trees. Two of these are on the inside and two are outside, again linking the chapel with the garden. A masonry wall on one side mirrors the neighbouring garden walls but is punctuated with windows and topped with a glass section adding to the light atmosphere of the chapel. The design was widely praised and has won multiple awards.

29. ST ANDREW'S AND ST GEORGE'S WEST, 13 GEORGE STREET, EH2 2PA

James Craig's original plan for Edinburgh's New Town would have seen churches at either end of George Street – St Andrew's Church at St Andrew's Square at the east end and St George's Church at a square bearing the same name at the west end. The western square was, in fact, eventually named after Queen Charlotte but a church dedicated to St George was, in due course, built there in 1811–14. At the

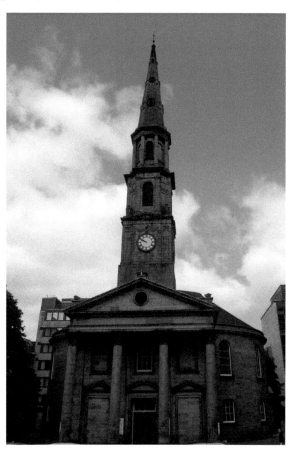

St Andrew's and St George's (West).

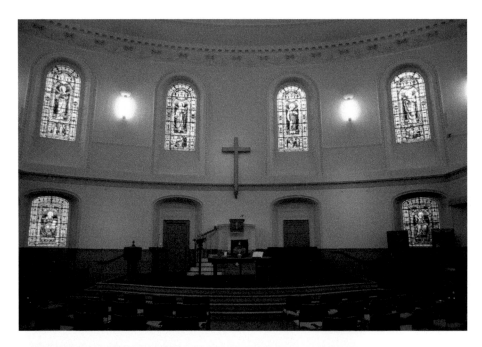

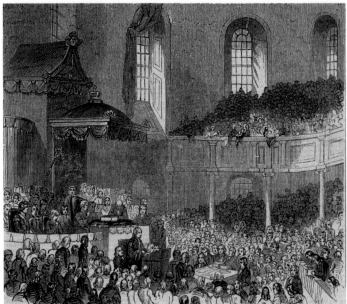

Above: Inside St Andrew's and St George's (West) – scene of the Disruption of 1843.

Left: Contemporary illustration of the Disruption meeting.

east end, however, St Andrew's Church was not built on the intended site, which had come into the ownership of businessman and politician Sir Laurence Dundas. Instead, it was built at the east end of George Street in 1782–84.

St Andrew's was designed by Major Andrew Frazer, chief army engineer for Scotland, in a neoclassical style. The Corinthian portico has a tall spire on top

which was added in 1787. The portico and spire help to obscure the elliptical shape of the main part of the building when viewed from the outside. The shape is more obvious from the interior, which also features some fine plasterwork on the ceiling and prominent stained-glass windows depicting the four Evangelists and David and Isaiah.

The most famous historical event to have taken place in St Andrew's was also one of the most important in Scottish ecclesiastical history – the Great Disruption. This major split in the Church of Scotland came about principally over the church's right to control its own affairs and appoint its own ministers without interference from civic authorities and local landowners. It was said that barely a tenth of those who wanted to could gain admission to St Andrew's on 18 May 1843 when the General Assembly of the Church of Scotland was held there. The retiring moderator, David Welsh, read out a statement and then led a large group of ministers and elders from the church to the Tanfield Hall at Canonmills where the first assembly of the Free Church of Scotland was held. Eventually, around a third of ministers left the Church of Scotland for the Free Church.

St Andrew's united with St Luke's in Queen Street in 1947, with St George's (which became West Register House) in 1964 and with St George's West in Shandwick Place in 2010.

30. St Anthony's Chapel, Holyrood Park, Queen's Drive, EH8 8JA

This ruined chapel in Holyrood Park overlooking St Margaret's Loch dates from at least the early fifteenth century. There is a record of Pope Martin V supplying funds for its repair along with vestments for the priest which dates from 1426.

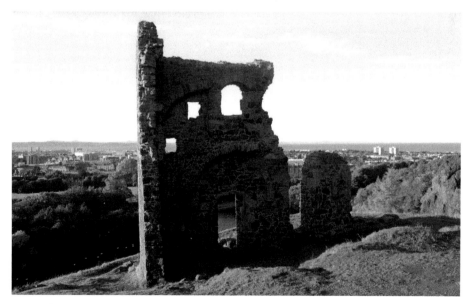

Ruins of St Anthony's Chapel.

Little is known of its history. It is situated in the part of Holyrood Park that was once under the ownership of Kelso Abbey. It has been suggested that there was a link with the Preceptory of St Anthony, a skin hospice founded in Leith by James I around 1430, but there does not appear to be any evidence of such a connection. There certainly seems to have been a graveyard associated with the chapel as human remains have been found there on several occasions over the years.

St Anthony's Chapel fell into disrepair in the years following the Reformation and was certainly a ruin by the mid-eighteenth century. Hugo Arnot, who was born in 1749, wrote in his *History of Edinburgh* in 1779:

> This was a beautiful Gothick building, well suited to the rugged sublimity of the rock. It was forty-three feet long, eighteen feet broad and eighteen high. At its west end there was a tower of nineteen feet square and, it is supposed, before its fall, about forty feet high. The doors, windows and roof were Gothick; but it has been greatly dilapidated within the author's remembrance; and ere long hardly a vestige of it will remain.

Fortunately, the ruin at least is still standing.

31. St Columba's Free Church, Johnston Terrace, EH1 2PW

Among the many noteworthy figures commemorated in stone in central Edinburgh is a clergyman whose statue stands in Princes Street Gardens facing out onto the street itself. The minister has a protective arm around a young child and the inscriptions on the plinth tell us that this is Thomas Guthrie and that he

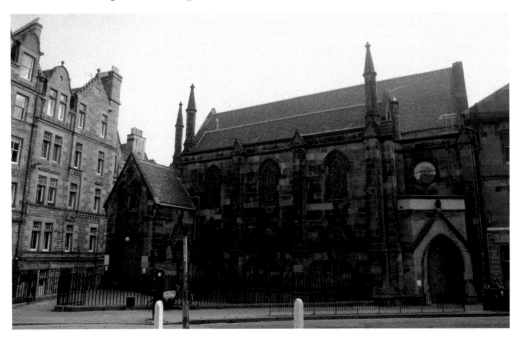

St Columba's Free Church.

was, among other things, 'an eloquent preacher of the gospel' and 'founder of the Edinburgh original ragged industrial schools'. Guthrie believed that for many of the impoverished children he met in Edinburgh, the type of schools he established provided 'their only chance of being saved from a life of ignorance and crime'.

In 1837 Guthrie became the minister of the second charge of Greyfriars Church, a post that was abolished three years later when a new church named St John's was built in Victoria Street and Guthrie became its minister. Three years after that, he was among those who left the Church of Scotland at the Disruption. At first, Guthrie and the members of his congregation who followed him worshiped in the Methodist Hall in Nicholson Square before moving, in 1845, to a new church in Johnston Terrace which was known as Free St John's but is now St Columba's Free Church. There is a memorial to Guthrie by the sculptor William Brodie in the church vestibule.

The church was altered in 1908 to make it more suitable for the Free Church General Assembly. As St Columba's, it remains home to a Free Church congregation and in the Summer months also welcomes visitors to the Christian Heritage Centre. The former St John's Church of Scotland building on Victoria Street that Guthrie and his congregation left, meanwhile, is still in existence but no longer serves a church.

32. St Columba's by the Castle, 14 Johnston Terrace, EH1 2PW

Built in 1846–7, this church was designed by John Henderson and founded by Revd John Alexander of St Paul's in Carruber's Close. With its square tower, it has the appearance of having been transplanted from a rural setting when viewed from Johnstone Terrace but is very much an urban church in the heart of Edinburgh's Old Town, built to serve the poor of the area. The terraced site was partly chosen so that it could accommodate a school below the church. This space is now used as a hall and other accommodation.

The church itself is said to have been constructed using stones taken from the ruins of the chapel in the palace of Queen Mary of Guise on Castle Hill. The interior has a relatively simple layout that would still be recognisable to a member of the first congregation, though the middle years of the twentieth century saw several changes. The rood screen which once separated the nave from the chancel was removed and the altar moved forward so that the priest could be facing the congregation. Perhaps the most striking change, though, was the removal of the east window which was filled in and replaced in 1959 by a mural by John Busby depicting Christ in Majesty. Busby was a member of the congregation and lecturer at the College of Art. He went on to have a successful career as artist, specialising in illustrations of wildlife. The church's name has also changed over the years to add 'by the castle' to distinguish it from its near neighbour St Columba's Free Church.

To the rear of the church is an attractive terraced garden which is regularly open to the public as part of the Quiet Garden Movement – a worldwide movement which seeks to promote access to outdoor space for prayer and reflection.

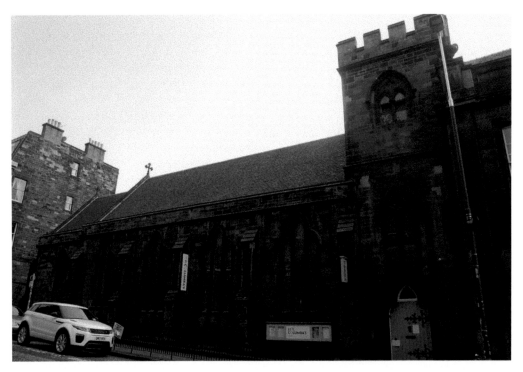

St Columba's by the Castle.

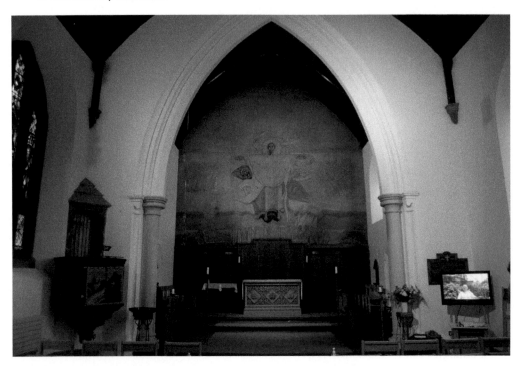

Interior of St Columba's by the Castle.

33. THE PARISH CHURCH OF ST CUTHBERT, 5 LOTHIAN ROAD, EH1 2EP

St Cuthbert's has a history that goes back a lot further than a glance at the current building might suggest. The earliest document referring to the church dates from 1127 when King David I granted a charter giving all the land below the castle to St Cuthbert's. The church is thought to long predate this, though, possibly dating back to the seventh century and the lifetime of St Cuthbert himself who may have built a small structure on the site. Some believe that the church was a later dedication to him, possibly by St Margaret.

For centuries, when Edinburgh consisted of a cluster of buildings in the shadow of the castle, St Cuthbert's served a large area of the surrounding countryside. Indeed, it may have even served the burgh itself, prior to the foundation of St Giles'. The parish would shrink over time, though, as chapels of ease founded by St Cuthbert's became parishes in their own right and other parishes were established.

The current church was dedicated in 1894, having been built to a design by Hippolyte J. Blanc. Evidence of at least six earlier church buildings were found when the previous church was demolished. Blanc's design retained the tower and steeple of its eighteenth-century predecessor.

Entering the main part of the modern church, the visitor is facing the apse where, above the 1894 communion table, is a modified version of Leonardo da Vinci's *Last Supper* in alabaster, split into three sections to fit the curve of

St Cuthbert's Parish Church from Edinburgh Castle.

Above: The Last Supper in alabaster, with stained-glass windows and a mural of Christ in Glory above.

Left: The font with a copy of Michelangelo's marble 'Bruges Madonna' on top.

the wall. Above these are three stained-glass windows depicting the Nativity, the Crucifixion and the Resurrection. Higher still is a mural by Robert Hope of Christ in Glory. On the chancel vault are images of the Four Evangelists by Gerald E. Moira.

On the left-hand side of the apse is the marble and alabaster pulpit which was designed by Blanc and features a relief panel of the Angel of the Gospel, while on the right is the font which is based on the one in Siena Cathedral but with a copy of Michelangelo's marble 'Bruges Madonna' on top. Above the gallery are several stained-glass windows, including an outstanding one by Tiffany of New York showing David with his sling on his way to fight Goliath.

In 1990, additional rooms were created from the existing church space. the Lammermuir Hall contains a bookshop and information about the church. There are two further meeting rooms decorated with images of St Cuthbert in a mural and stained glass.

The Memorial Chapel is at the west side of the building and actually forms part of the previous church building dating from 1775, being in the base of the retained tower. Its communion table sits in a striking apse with gilt mosaic on the walls and a stained-glass window depicting the crucifixion. The other walls of the chapel are covered with marble panels with the names of the war dead.

Although she is forever destined to be known by her first husband's surname, the novelist Agatha Christie's more enduring marriage was her second one to the archaeologist Max Mallowan which took place in the Memorial Chapel in 1930.

The Memorial Chapel.

It is likely that St Cuthbert's was chosen because Christie's secretary (who doubled as a governess for her daughter) was a woman named Charlotte Fisher whose father, Robert, had been the minister there. Miss Fisher and her sister Mary were the witnesses to the ceremony. The low-key wedding clearly met Agatha Christie's expectations as she later recalled in her autobiography, 'Our wedding was quite a triumph - there were no reporters there and no hint of the secret had leaked out.' The couple's honeymoon involved a (presumably inspirational) trip on the Orient Express.

St Cuthbert's kirkyard is the last resting place of many notable people including John Napier, the inventor of logarithms, the artists Sir Henry Raeburn and Alexander Naysmith. The graveyard is overlooked by a watchtower built to deter grave robbers.

34. St Giles' Cathedral or the High Kirk of Edinburgh, High Street, EH1 1RE

Much of the history of Christianity in Scotland and, indeed, of Scotland itself can be traced through the history of St Giles'. Even the names given to the building have much to tell us. The name of St Giles, a sixth-century monk or hermit who was the patron saint of lepers and popular in medieval times, betrays its Catholic origins; 'Cathedral' – meaning the seat of a bishop – is a legacy of the period of Episcopal government of the Church of Scotland and 'High Kirk' brings to mind the church's place as the home of Scottish Presbyterianism. So much history is encapsulated in this single building and so numerous are its interesting features that it will only be possible to touch upon some of them here.

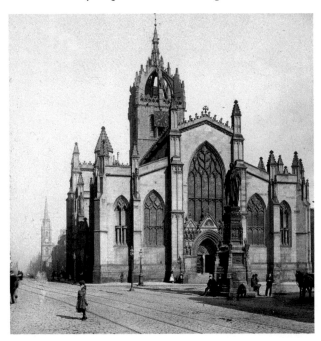

Old Magic Lantern slide view of St Giles'.

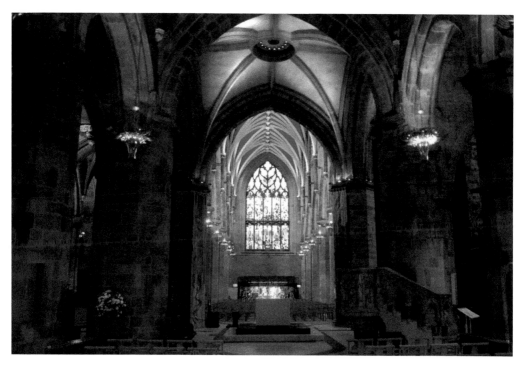

View of the nave looking towards the Robert Burns memorial window.

It is commonly believed that the church of St Giles was founded by King David I in the early twelfth century around the same time as the Burgh of Edinburgh itself. It may have been a daughter church of St Cuthbert's parish, which seems to predate it. A doorway, apparently from the time of the original St Giles' Church, survived until 1796. The rest of the building, however, was much altered over the centuries, not least out of necessity following damage suffered in English raids on Edinburgh in 1322 and 1385.

St Giles' was rebuilt and greatly expanded and in 1466 became a collegiate church. By the mid-sixteenth century, there were said to be fifty side altars in the church, dedicated to different saints. At this time, however, the Reformation was in the air and in 1559, a former Catholic priest named John Knox, who had converted to Protestantism, returned from exile in Geneva and was elected the minister of St Giles'. He oversaw the removal of the altars and statues and other furnishings, the melting down and sale of precious objects, the removal of stained glass and the whitewashing of the walls. In the year following Knox's election, Scotland officially became a Protestant country when Acts of Parliament ending Papal authority and prohibiting the Mass were passed.

When Knox died in 1572, he was buried in the kirkyard of St Giles'. This has long since been paved over and part of it now forms Parliament Square. A marker on one of the car parking spaces commemorates the site of his grave. It was not until 1906 that a statue of Knox was unveiled in St Giles'. Its initial position, on a plinth and underneath a Gothic arch, seems unlikely to be something of which

Knox himself would have approved. The statue later spent many years outside the church but returned to the inside in 1983 where it now stands on the floor against the north wall.

Knox is not the only formidable figure in the religious history of Scotland to be commemorated in St Giles'. A sculpture of a three-legged stool represents the one reputedly thrown by Jenny Geddes at Dean James Hannay in 1637 in protest at the new English-style prayer book introduced by King Charles I. There is some question as to whether Geddes herself actually existed but there is no doubt that the sentiment expressed in her story was a popular one at the time.

Left: Statue of John Knox.

Below: Exterior of the Thistle Chapel.

From the late sixteenth century St Giles' was split into four (later three) separate parishes and the building divided accordingly. The divisions remained until the 1870s when a major restoration was undertaken. This was not the first renovation of the nineteenth century. One was carried out by William Burn between 1829 and 1833 which saw the remodelling of most of the exterior and the raising of the height of the roof of the nave.

The later restoration was carried out by the architect William Hay at the behest of Edinburgh's former Lord Provost William Chambers. The opened-up church was now orientated to face the communion table at the east end and chairs were installed in the nave. In the late twentieth century, a central communion table was installed in the crossing with seats facing from both directions. A new marble table designed for the space was dedicated in 2011. The period of the Chambers restoration also saw the reintroduction of stained glass to St Giles' for the first time in 300 years. Much of it was the work of the Edinburgh firm James Ballantine and Co. Many fine examples were added in the following century, culminating in the great west window added in 1985, in memorial to Scotland's national poet Robert Burns. There are also memorial plaques to other writers and national figures including Robert Fergusson and Robert Louis Stevenson and many military memorials including ones to the dead of the world wars.

Among the other notable features of the interior is a survivor of all the work carried out – the King's Pillar at the east end of the building, thought to date from 1451, which displays the coats of arms of King James II of Scotland, his Queen, Mary of Guelders, and their son, who became James III. The great survivor of the exterior is the central tower with its crown spire also dating from the fifteenth century.

The most important addition to St Giles' since the Chambers restoration is the Thistle Chapel which was designed by Robert Lorimer and completed in 1911 to provide a home for the Order of the Thistle. The narrow chapel is situated at the north-east of the building and is highly decorated with a remarkable vaulted ceiling and stained glass. Along the walls are the canopied stalls for the Knights or Ladies with the Sovereign's stall at the west end.

The Order of the Thistle was instituted in 1687 by King James VII, supposedly reviving an earlier order. Appointment to the Order is the personal choice of the Sovereign and is considered to be Scotland's highest honour. Besides the Sovereign and other members of the royal family, membership of the Order is limited to sixteen Knights or Ladies. Fortunately, however, you do not have to be a member to visit the chapel and like the rest of St Giles', it is regularly open to visitors.

35. St John's Episcopal Church, 1A Lothian Road, EH1 2AB

The congregation of St John's Episcopal Church predates the building, having been formed in 1792 when twenty-six-year-old Daniel Sandford began to minister to a group of Episcopalians in West Register Street. The growing congregation later moved to new premises in Rose Street. Initially, the group had operated outwith the jurisdiction of the Scottish Episcopal Church but by 1806, not only had there been a reconciliation but Sandford had been appointed Bishop of Edinburgh.

It was originally planned that a large church be built at the foot of the Mound to house both Sandford's congregation and that from the Cowgate Chapel but

St John's Episcopal Church.

The nave of St John's.

A section of the magnificent stained glass.

instead it was decided that two churches would be built: St Paul's at York Place and St John's at the west end of Princes Street. The new building was designed by Edinburgh architect William Burn in a Gothic style and was built between 1815 and 1818, creating a stunning landmark marking the junction of Princes Street and Lothian Road.

The interior is flooded with colourful light from numerous stained-glass windows under a magnificent vaulted ceiling which is modelled on King Henry VII's Chapel in London's Westminster Abbey. The stained-glass was added in several stages from the mid-nineteenth century, most of it the work of three generations of the Ballantine family. There are several interesting memorials on the walls of the nave as well, among them one to John Stuart Forbes who was killed at the Battle of Little Big Horn (known to Native Americans as the Battle of the Greasy Grass and to others as Custer's Last Stand) in 1876.

When the church opened there was an east wall which was mainly taken up with a large painted window. The chancel was added in 1882. The pulpit and choir stalls date from 1910. The stalls were based on those in King's College Chapel, Aberdeen. Above the high altar is a reredos depicting the Virgin Mary and St John flanking a central image of Christ which reflects the stained-glass windows above.

A large vestry hall was built between 1914 and 1916. Between this and the south wall of the chancel a morning chapel designed by W. J. Walker Todd was added in the 1930s. The hall was extended and reorganised in 2017 by LDN Architects to provide space for a variety of functions. The terrace underneath the

church houses the Cornerstone Bookshop, Red Cockerel Cafe and One World Shop. Collectively these facilities form the Cornerstone Centre.

Outside the church are two hand-carved granite sculptures by Ronald Rae: *Famine* and *The Mark of the Nail*. Among the memorials in the graveyard are ones to painter Sir Henry Raeburn and Anne Rutherford, Sir Walter Scott's mother, as well as the church's founding father, Daniel Sandford. On the Princes Street side is a large granite Celtic Cross in memory of Dean Ramsay who served St John's for many years in the nineteenth century. Among the clergy who served in the twentieth century was William Henry Bridge who was the grandfather of the American folk singer Joan Baez, someone who has long campaigned on social justice issues – a theme often reflected in the striking murals that are to be found outside the church.

36. ST MARGARET'S CHAPEL, EDINBURGH CASTLE, EH1 2EL

On the highest part of Edinburgh's Castle Rock stands the city's oldest building, a small rectangular place of worship dating back to the early years of the twelfth century and known as St Margaret's Chapel. Margaret was a princess of the English Royal House of Wessex. Her family had been exiled to Hungary by King Cnut but returned to England in 1057 only to flee north following the Norman Conquest. She later married the Scottish King Malcolm III.

Queen Margaret was known for her piety and acts of charity. She established a crossing point on the Firth of Forth for pilgrims on their way to St Andrews Cathedral, remembered to this day in the names of North Queensferry and South Queensferry. She died in 1093 and was canonised by Pope Innocent IV in 1250.

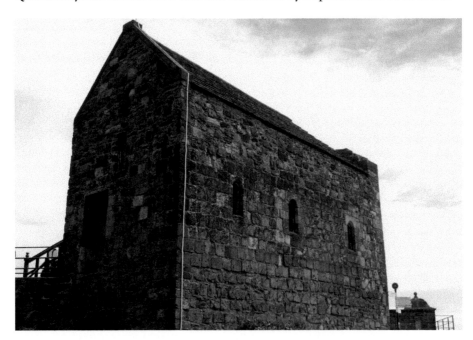

St Margaret's Chapel, Edinburgh Castle.

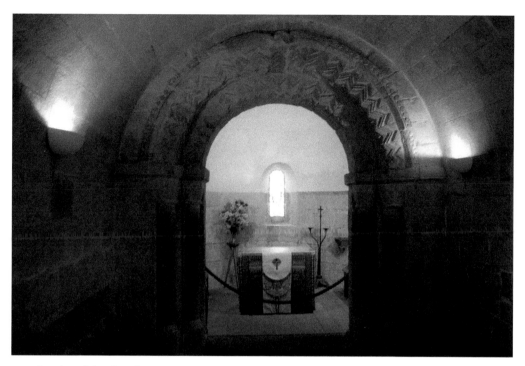

Interior of the chapel.

It was long thought that St Margaret herself had worshipped in the chapel but the architectural style points to it having been built by her son King David I around 1130, though it was undoubtedly constructed on a spot she would have known and may have favoured. The chapel survived the destruction of the castle by the forces of Robert the Bruce in 1314 but faced centuries of neglect following the Reformation when it was used as a gunpowder store. Its true purpose was only rediscovered by Sir Daniel Wilson in the nineteenth century. The building was renovated in the 1850s when a version of the original vaulted ceiling was restored to the nave. Five stained-glass windows by Douglas Strachan depicting St Margaret, St Andrew, St Columba, St Ninian and William Wallace were added in 1922.

The restoration of the building, however, did not restore the respect it deserved. By the early 1930s, it was being used for the sale of picture postcards. Dr Warr of St Giles' complained that he had seen the people in the chapel 'with their hats on and cigarettes in their mouths'. David Russell of the Iona Fellowship proposed returning the chapel to its original purpose even if it just meant installing a small communion table and lectern. This was duly done and the chapel was rededicated on 16 March 1934. A further rededication came in 1993, following a major refurbishment to mark the 900th anniversary of St Margaret's death.

The chapel furnishings are looked after by the St Margaret's Chapel Guild which was founded in 1942. The guild also ensures that fresh flowers are placed in the chapel twice weekly. All members of the guild are called Margaret or have it as a middle name.

37. ST MARGARET'S PARISH CHURCH, 29 RESTALRIG ROAD SOUTH, EH7 6LF

The historic village of Restalrig (known at different times as Lestalryk, Restalric or Rastalrig) has been swallowed up by the city of Edinburgh over the last century but the original settlement, with St Margaret's Parish Church at its heart, is still discernible today.

The story of Christian worship in the area goes back to St Triduana who tradition says died and was buried there. Little is known for definite of Triduana's life. She is reputed to have been born in Clossae in modern-day Turkey and to have come to Scotland in the fourth century AD with the equally obscure St Rule who brought the relics of St Andrew to Fife. She is then said to have settled at Rescobie near Forfar where she attracted the unwanted attentions of the King of the Picts who admired her beautiful eyes. Triduana took the drastic step of tearing out her own eyes and presenting them to the king. After her death at Restalrig, her tomb and a nearby well became important places of pilgrimage. She was particularly associated with the curing of eye disorders.

There is evidence for the building of a church at Restalrig in 1165 by Edward de Lestalric and its subsequent completion by his son Sir Thomas. This church was rebuilt at the start of the fifteenth century. It was clearly of interest to King James III, who ordered a two-storey hexagonal royal chapel with an altar dedicated to St Triduana to be built there in the fifteenth century.

The church and its associations came to the attentions of the Reformers in 1560 who ordered that 'the kirk of Restalrig, as a monument of idolatry, be raysit and utterlie cast down and destroyed'. This was not fully carried out in that the lower

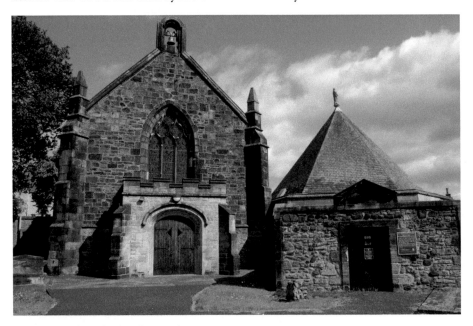

St Margaret's Parish Church, Restalrig.

St Triduana's Chapel.

chamber of the king's chapel survived. It was later used as a burial vault but was excavated and restored in the early twentieth century and a roof was added.

The church itself had been rebuilt to a design by William Burn in 1836 and dedicated to St Margaret. A stained-glass window depicting her was installed in 1966 along with two others – one dedicated to St Dorcas and another which showed St Triduana. Triduana's name is also perpetuated in the name of the nearby Roman Catholic church which is jointly dedicated to her and St Ninian.

38. St Mary's Episcopal Cathedral, Palmerston Place, EH12 5AW

In March 1870, an eighty-six-year-old woman named Mary Walker died. Her sister Barbara had predeceased her in 1859. Neither woman was married or had any children. The sisters left money and land by way of a trust to the Episcopal Church in Scotland. The Walkers stipulated that a cathedral church be built on a site at the west end of Melville Street; in fact, in the garden of their house, Easter Coates House. The cathedral was to be named St Mary's and dedicated to the Virgin Mary but also in honour of the sisters' mother, Mary Drummond. Easter Coates House survives and is now part of St Mary's Music School.

Sir George Gilbert Scott won the architectural competition to design the cathedral with a Gothic design. The building follows a cruciform pattern, with the most striking features of the exterior being the three spires. The two at the west are 197 feet (60 metres) high while the centre tower and spire reach up some

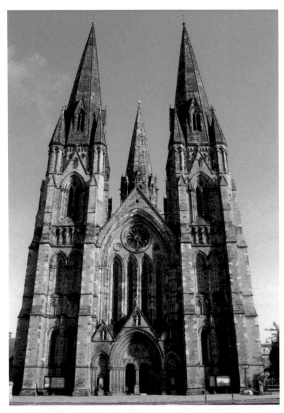

Left: St Mary's Episcopal Cathedral.

Below: The nave.

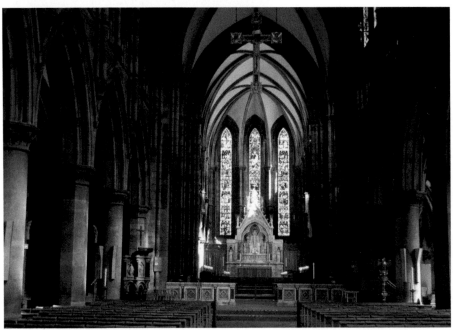

295 feet (90 metres) and are claimed to be the tallest in Edinburgh. It was not until 1917 that the building was completed.

Inside the cathedral, the long nave leads to the high altar beyond the choir. An altar facing the people is commonly used today but the original layout remains. The reredos depicting the Crucifixion was sculpted by Mary Grant.

The Henry Willis organ in the north transept dates from 1879 and is well situated for the choir. Choral music is particularly important in the cathedral, which is unique in Scotland in maintaining its own choir school. The choir has been internationally acclaimed and features on many recordings. In 1978, new ground was broken when girls were allowed to sing alongside boys in the treble line and in 2006, when the first female alto was admitted. Visitors to the cathedral have the opportunity to hear the choir at regular daily Choral Evensong services as well as on Sundays.

The Lady Chapel in the south chancel aisle is by George Henderson and is demarcated by a metal screen. There are stained-glass windows throughout the cathedral but perhaps the most noteworthy are the windows in the south transept by Sir Eduardo Paolozzi that were installed to mark the millennium.

A curiosity to look out for in the cathedral is Sir Walter Scott's pew. It is curious because the novelist was not only a Presbyterian but died long before the cathedral was built. The pew originally came from St Paul's Church in York Place and are thought to have been occupied by Scott's wife, Charlotte.

Sir Walter Scott's pew.

39. St Mary's Catholic Cathedral, Broughton Street, EH1 3JR

The Metropolitan Cathedral of Our Lady of the Assumption had its origins in 1814 when it opened as plain St Mary's Chapel, huddled among the tenements of Broughton Street. Behind the Gothic façade, the chapel, which was designed by James Gillespie Graham, was a simple rectangular building with a flat roof. Its evolution into the modern cathedral was gradual, reflecting, perhaps, the tentative re-emergence of the Catholic Church into public life in the nineteenth century. In 1841, the chapel's sanctuary was enlarged and in 1866 a cloister was built at the side that now houses Lady Chapel. This was superseded in the 1890s when the side walls of the church were turned into arches, with aisles added to each side. The priests' house in Chapel Lane was demolished allowing for extension of the sanctuary.

Major changes to the church's status were to follow – in 1878 following the restoration of the Scottish hierarchy when it became a cathedral and in 1886 when it became the Metropolitan (senior) Cathedral for the East of Scotland. The most dramatic structural change came in 1932 when the roof was raised to its present height. Further changes were made to the building's exterior in the 1970s with the demolition of the front porch and the baptistry and addition of a new porch to the side. The demolition of nearby tenements in this period meant that the original façade was fully visible and the building became the landmark that we see today. A new parish centre was built on the porch side and opened in 2005. Today this is home to Coffee Saints, a social enterprise café, resulting from a partnership between the cathedral and the Grassmarket Community Project and also to St Paul's bookshop.

There are many features of note in the cathedral. In the porch is a painting depicting Christ's Deposition from the Cross. This painting was among the artworks

St Mary's Roman Catholic Cathedral.

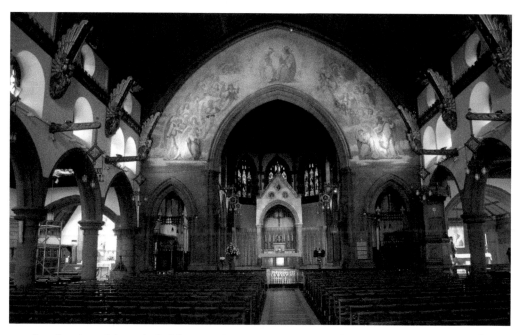

Interior view of the cathedral featuring Louis Beyart's painting of the Coronation of the Blessed Virgin Mary as Queen of Heaven above the chancel arch.

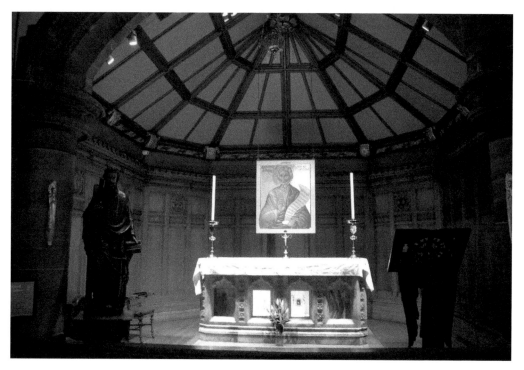

National Shrine to St Andrew.

that had to be evacuated back in 1865 when the building was threatened by one of several fires that started in the neighbouring theatre. The theatre burned down for the last time and 1946 and the church acquired the site on which the porch now sits.

In the nave the brightly coloured angels above the arches are actually corbels helping to keep the roof in place. Above the sanctuary arch is a large painting by Belgian artist Louis Beyart depicting the Coronation of the Blessed Virgin Mary as Queen of Heaven. It is not, as might be thought, a mural, but a painting on canvas that was cut to size.

The sanctuary itself has been reordered over the years. The baldacchino dates from 1928 and the marble altar came from the former Catholic Apostolic Church at Bellevue, while the pedestal that supports the tabernacle was formed out of materials from the cathedral's old high altar. Beneath the sanctuary is the last resting place of several of the Archbishops of St Andrews and Edinburgh including Cardinal Gray, the first resident Scottish Cardinal since the Reformation.

The Lady aisle, to the left of the sanctuary, contains a war memorial by Mayer of Munich as well as the Stations of the Cross. On the other side of the sanctuary is the National Shrine to St Andrew which replaced the one in St Andrews in Fife which was destroyed in 1559. Its altar contains two relics of the saint. Pope John Paul II prayed at the shrine on his visit to the cathedral in 1982.

Pope St John Paul is perhaps the most famous person to have worshipped in the cathedral but he is not the only person of note to have done so. In 1830, the then St Mary's Chapel was attended regularly by the deposed King Charles X of France and among those baptised there was the creator of Sherlock Holmes, Arthur Conan Doyle, who was born nearby at Picardy Place. In the baptismal records he has the additional middle name 'Ignatius' which does not appear on his birth certificate, leading to speculation that the saint's name may have been a suggestion from the priest at the time.

40. ST MARY'S STAR OF THE SEA, 106 CONSTITUTION STREET, LEITH, EH6 6AW

The foundation stone for what would become St Mary's Star of the Sea in Leith was laid by Bishop Gillis on 25 March, the Feast of the Annunciation, in 1852. The completed building, which opened two years later, was the first Catholic Church to have been built in Leith since the Reformation, though a mission had been established in the port under Father Thomas Carlyle in 1847. The seventeenth-century Balmerino House and its grounds were purchased in 1848 to provide a site for a church, school and presbytery. Catholics were an impoverished and often unpopular minority in Leith at this time. Indeed, Bishop Gillis had faced hecklers from nearby tenements during the stone-laying ceremony.

In 1859, the Oblates of Mary Immaculate, an order founded in France in 1816 by St Eugene de Mazenod, took over the running of the church, and the parish remains in their care today. In 1980, their mission was expanded to take in St John Ogilvie's Church in Wester Hailes.

The church was designed by Edward Welby Pugin and Joseph Aloysius Hansom (inventor of the Hansom cab) but when built it lacked the present chancel and

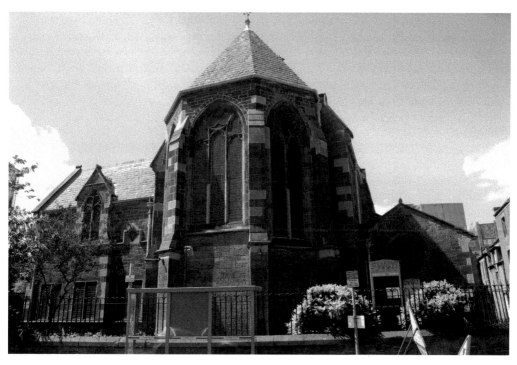

St Mary's Star of the Sea, Leith from Commercial Street.

View of St Mary's Star of the Sea from the church entrance.

north aisle and was orientated to the west. The north aisle was added in 1900 and the chancel, designed by Peter Paul Pugin, was built in 1911–12. This facilitated the re-orientation to the east and explains why the visitor entering from Constitution Street now has to walk the length of the building to find the door. Despite these alterations, there is little visible inside the church to suggest that the building is not as it was always intended.

The interior is generously furnished with statues and stained-glass windows. The central east window depicting the Crucifixion is by the Clokey Stained Glass Studio in Belfast and dates from 1955 and, as such, is of a more modern style to the windows on either side which date from the 1880s and were moved to this position on the completion of the chancel.

Also of note is the tomb-chest effigy of Father John Noble, the first Superior of the Oblate community at Star of the Sea who tragically drowned in Leith Harbour in 1867 at the age of forty-three. Father Noble, who was born in Dublin, had been instrumental in setting up the parish school and building the presbytery.

41. St Michael and All Saints, 28 Brougham Street, EH3 9JH

Work began on All Saints Church in 1866 to provide a home for a congregation arising out of a mission school formed in 1853 in Earl Grey Street, which was itself an offshoot of St John's Church on Princes Street. When Dean Ramsay laid the foundation stone for the new church, he mused, 'it would be curious to look forward to the future of this building'. He would surely be happy to know

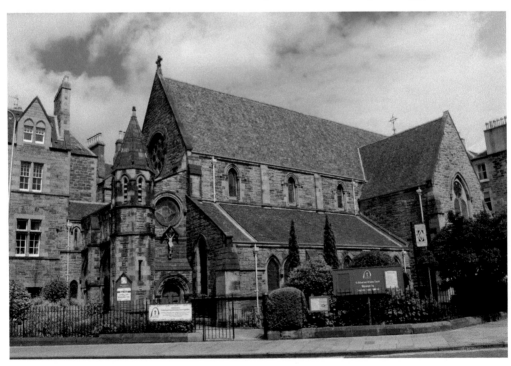

St Michael and All Saints.

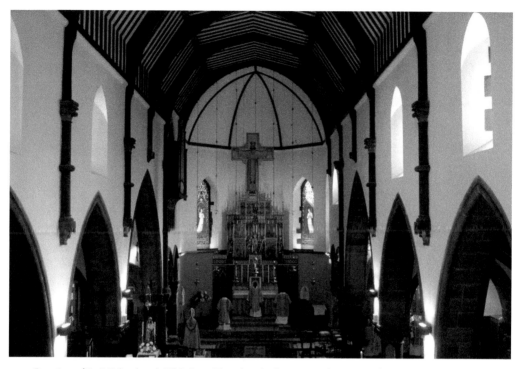

Interior of St Michael and All Saints. The ghostly figures are from an exhibition of vestments.

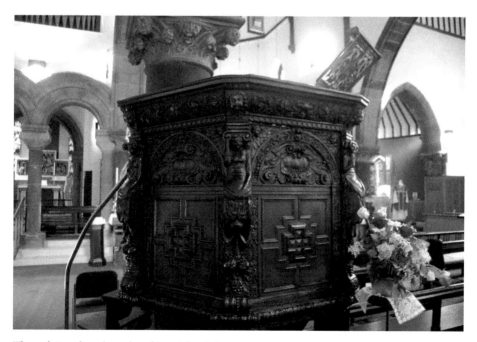

The pulpit – thought to be of Spanish origin.

that the church, which became St Michael and All Saints following a union in 1965 with St Michael's Church in Hill Square, continues to serve the area in the twenty-first century.

The original building, designed by Robert Rowand Anderson, opened in 1867 and consisted of the nave and aisles, transepts, chancel and the present St Michael's Chapel. A steeple was intended for the south-west corner but was not completed due to a shortage of funds. Instead, an extension including a turret was added in 1876. In 1897, the Lady Chapel was added at the north-east. Both later additions were also designed by Anderson, giving the building a consistency that it might not otherwise have had.

There are many fine features inside the church, some of which were brought from the Hill Square church, including the marble high altar. The wooden painted reredos by Charles Eamer Kempe, however, was made for All Saints but not installed until 1889, necessitating the blocking of the original east window. The stained glass from this window, depicting the Crucifixion, was moved to a window inserted on the south side of the chancel. The altarpiece by William Burges showing the Annunciation which was originally situated over the high altar is now to be found in the Lady Chapel. Meanwhile the chapel dedicated to St Michael situated to the south of the chancel contains the altar and altarpiece which used to be in the Lady Chapel of St Michael's Church. The carved wooden pulpit also came from St Michael's but is believed to have originated in Spain in around the seventeenth century, having been gifted to the church by the Earl of Kinnoull.

There is fine stained glass throughout the church. There are two windows showing angels in the chancel which originally flanked the Crucifixion. All three were installed in 1867 and are by William Wailes, of Newcastle. Other windows include works by Clayton and Bell, Charles Eamer Kempe and J. Ninian Comper. An unusual one to look out for is the 1917 depiction of St Joan of Arc by Amy Dalyell and Alexander Strachan which is on the west clerestory window on the south side.

42. St Patrick's, Cowgate, EH1 1NA

The Cowgate Chapel – the church that would become St Patrick's – was originally built for an Episcopal congregation between 1771 and 1774. The building was orientated to the east and culminated in an apse decorated with paintings by the renowned Edinburgh artist Alexander Runciman. When the Episcopalians moved to the new St Paul's in the New Town in 1818, it became home to a congregation of the Relief Church and then in 1828, the building was sold to the United Secession Church (both of these denominations later became part of the United Presbyterian Church).

In the wake of failure of successive potato crops in Ireland the late 1840s, the number of Irish immigrants to Edinburgh, the vast majority of whom were Roman Catholic, greatly increased and many settled in the Cowgate area. In 1856, the Catholic Church bought the Cowgate Chapel for the sum of £4,300, with half the money being raised by the local people, despite their poverty. The church was renamed St Patrick's after Ireland's patron saint.

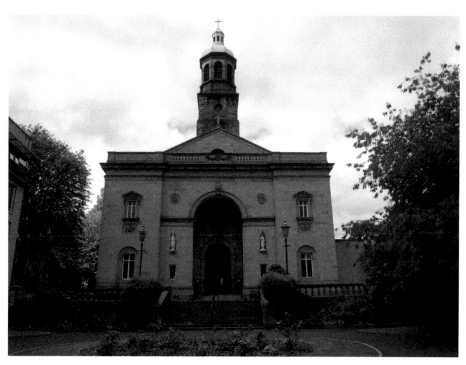

St Patrick's in the Cowgate.

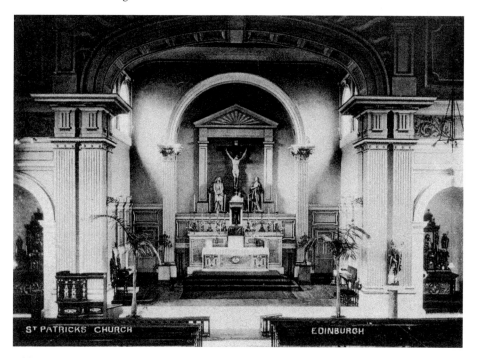

Old postcard view showing the sanctuary of St Patrick's.

In 1865, the priest Edward Joseph Hannan set up a branch of the Catholic Young Men's Society at St Patrick's to keep his young male parishioners out of trouble. Out of this, in 1875, a football club was formed. The club, which was named Hibernian to reflect its Irish origins, continues to thrive today and currently plays in the Scottish Premiership. There is a memorial plaque to Canon Hannan and another commemorating the foundation of the football club in the church foyer.

In 1898, the church was realigned with a new sanctuary and high altar being added to the north wall. This left the apse on the east side as a side chapel but it was without the mural of the Ascension of Christ on its ceiling painted by Alexander Runciman, which had been painted over by the Presbyterian congregation. The painting is thought to survive intact and in recent years a project has begun to restore it and the other paintings in the apse.

In the 1920s, St Patrick's began to take on its modern appearance externally with the addition of a façade to the south wall, complete with statues of St Patrick and St Brigid and the motto from the writings of St Patrick: 'UT CHRISTIANI ITA ET ROMANI SITIS' ('as ye are Christians so also be Romans'). Additions were also made to the interior in this period. A Lady Chapel was added to the east side of the sanctuary and a chapel dedicated to the Sacred Heart was added to the west. In 1921 a memorial chapel was erected to commemorate the 311 men from the parish who had been killed in the First World War.

In 2003, the Sacred Heart chapel became the final resting place of Margaret Sinclair, the Edinburgh factory worker whose case for sainthood is being considered by the Vatican. She was born in 1900 and was baptised at St Patrick's. She lived in Blackfriars Street and attended St Anne's School in the Cowgate. Margaret left school at the age of fourteen and worked as an apprentice French polisher and later in a biscuit factory. She was also an active trade unionist. In 1923 she entered the convent of the Poor Clares in Notting Hill, London, where she died of tuberculosis at the age of twenty-five. Her quiet devotion in her ordinary life and in her final illness inspired people and calls for her canonisation began soon after her death. In 1978 Margaret Sinclair was declared by Pope Paul VI to have 'practised the Christian virtues to a heroic degree' and was given the title Venerable.

43. ST PAUL'S AND ST GEORGE'S, 46 YORK PLACE, EH1 3HP

This Gothic Revival church, originally known as St Paul's, was built in 1816–18 by Archibald Elliott to house the Episcopal congregation from the Cowgate. There was already an Episcopal congregation in York Place, however, who met at St George's Church on the other side of the road. The two congregations merged in 1932 and the former St George's is now a casino.

Elliott's design appears to have been inspired by King's College Chapel in Cambridge with the distinctive octagonal turrets on the corners being based on those on St Mary's Church, Beverley, Yorkshire. Alternations were made to the building in 1891–92, when the east end was extended and the galleries that were situated in the aisles were removed. Over a hundred years later, new glass-fronted

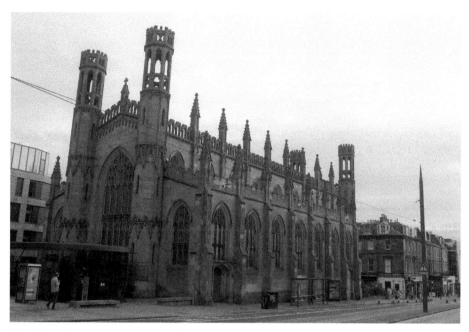

St Paul's and St George's – commonly known as Ps and Gs.

aisle galleries were constructed during an award-winning renovation by Lee Boyd architects completed in 2008 which also added the modern steel and glass entrance pavilion.

44. ST PETER'S, 77 FALCON AVENUE, EH10 4AN

The building of a new Catholic church was not something that was universally welcomed in early twentieth-century Edinburgh. In April 1906 when the foundation stone for St Peter's was laid, the *Musselburgh News* wrote, 'This new building in the Morningside district speaks of still further effort on the part of the Roman Catholic Church to captivate and pervert the upper and middle classes by an appeal to the sensuous.' Perhaps the author was thinking of the significant number of writers and artists who were followers of the Aesthetic Movement who had converted to Catholicism in the 1890s. Among these were the poet John Gray (though his origins were certainly not upper or middle class) and his friend Marc-André Raffalovich, a poet and wealthy patron of the arts. The two men had been associates of Oscar Wilde and, indeed, it is widely believed that Gray was the inspiration for the central character in Wilde's only novel, *The Picture of Dorian Gray*.

John Gray was ordained a priest in 1901 and took up a position at St Patrick's. Working among the poor in the Cowgate took its toll on his health, however, and it was at this point that Raffalovich offered to finance a proposal to solve the need for a Catholic church in Morningside and also provide 'a means of giving suitable employment to Fr Gray'. It was an offer that was accepted by Archbishop Smith.

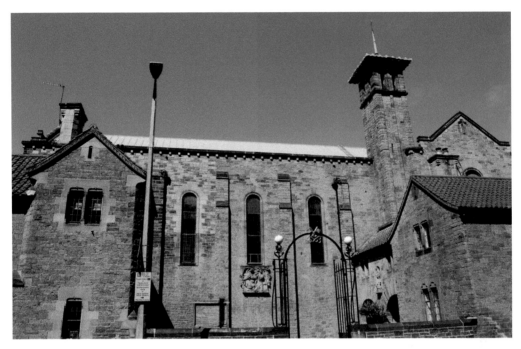

St Peter's RC Church, Morningside.

The architect chosen to create the Romanesque-style church was Robert Lorimer. The first phase of the church was built in 1906–7 but the second was not completed until 1928–29, by which time the Hailes Quarry, from where the original stone had been sourced, had closed – a fact that is still evident on the outside of the building. There are several sculptures on the building's exterior including representations of the Crucifixion, the Annunciation, St Joseph and the four beasts which traditionally represent the Evangelists. On the outside of the priest's house a Guardian Angel protectively holds a model of the house itself.

The church is entered via a courtyard with the campanile to one corner. The gateway to the courtyard has the keys of St Peter above and the saint is represented inside the church in several other ways. The keys are represented again in an ocular window, while there is also a bronze replica of the famous statute in St Peter's in Rome. Near the statue is the painting *Confession of St Peter* by the Welsh artist Sir Frank Brangwyn which formerly adorned the sanctuary wall. That wall now houses a carved wooden depiction of the Crucifixion with Our Lady and St John which mirrors the stone version on the outside wall.

The nave is tall and whitewashed with exposed brick on the lower pillars, reaching up to a wagon roof ceiling. This apparently austere appearance is mitigated by numerous artistic flourishes. Among the stained glass are various intricate pieces by Alice and Morris Meredith Williams as well as three windows featuring glass set in concrete by Pierre Fourmaintraux. The mosaic Stations of the Cross by John Kingsley Cook and George Garson replaced earlier ones by the Dundee artist John Duncan. Among the paintings which adorn the walls

is a copy of *Our Lady of the Snow* which Father Gray brought back from in Rome in 1905. There is a recurring fish motif, an ancient symbol of Christianity and a representation of St Peter the fisherman. It can be found in marble on the Communion step, in wrought iron on a hanging roundel and on a radiator grille as well as on the lead baptismal font where it also represents water as one of the four elements.

45. South Leith Parish Church, Kirkgate, Leith, EH6 6BJ

Today South Leith Parish Church and its surrounding graveyard provide an oasis of calm in the busy Kirkgate district of Leith but its appearance belies a long and turbulent history. The church was founded as a chapel dedicated to the Virgin Mary in the late fifteenth century. In 1544, it provided refuge for local people after Henry VIII of England ordered Leith to be burned during the 'Rough Wooing'. Three years later it was used as a prison for Scottish nobles during another

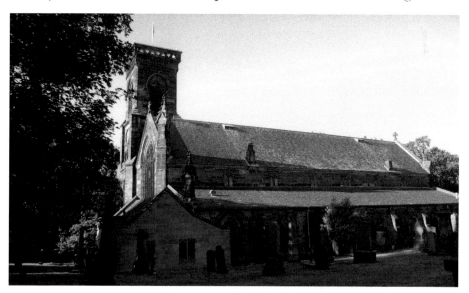

Above: South Leith Parish Church.

Right: Some of the cannonballs which hit the church in 1560.

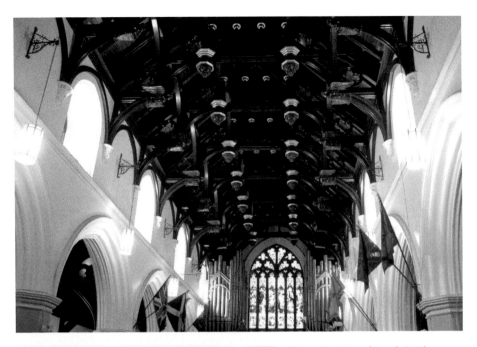

Above: Interior of South Leith Parish Church showing the hammerbeam roof.

Left: The arms of Mary, Queen of Scots.

English invasion. In 1560, the chancel and crossing were destroyed during the bombardment of Leith by English forces who had come to the aid of the Protestant Reformers. Cannonballs from this attack are on display in the church entrance.

In 1609, the repaired church officially became a parish in its own right, having originally been part of the Parish of Restalrig. A few years later, a steeple was added at the west end of the building. It might have been thought that by this time the church could settle down to normal parish life but the mid-seventeenth century brought new problems in the form of the plague, which devastated Leith in 1645. The Kirk Session arranged for food to be left at the doors of houses where the plague was and built 'ludges' on the Links for the families of victims.

The church's steeple was demolished in the 1830s and the entire building was rebuilt at that time to a design by Thomas Hamilton which incorporated some elements of the original, notably the nave arcades. One element that was not retained was the clear-glass west window which has since been incorporated into the Bruce Chapel in St Conan's Kirk, Loch Awe. The rebuilt church, however, gained a magnificent hammerbeam roof.

On display at the church are the arms of Mary of Guise dated 1560 which are thought to have come from her residence in Water Street and those of her daughter Mary, Queen of Scots, dated 1565 which came from the old Leith Tolbooth demolished in 1825. Two further generations are represented on the exterior of the tower with the arms of James VI and Charles I.

Among those buried in the graveyard are John Pew, a maltman who died in 1750 and whose name is thought to have inspired Robert Louis Stevenson, whose Balfour relatives are buried nearby, to name the character 'Blind Pew' in *Treasure Island*. Before Constitution Street was opened in the late eighteenth century, the graveyard extended further to the east and recent work to extend the tram network to Newhaven has uncovered hundreds of bodies. It is hoped that the examination of these remains will shed light on many aspects of the history of Leith.

46. Trinity Apse, Chalmers Close, High Street, EH1 1SS

Around 1460 Mary of Guelders founded a collegiate church, together with an almshouse, Trinity Hospital, as a memorial to her husband, King James II, who was killed at the Siege of Roxburgh. The church was to be sited in the valley between the Old Town and Calton Hill. The nave does not appear to have ever been completed but the choir and transepts acted as the parish church for the north-east part of Edinburgh from the late sixteenth century until the 1840s when the area was acquired by the North British Railway Company for inclusion in what was to become Waverley Station.

The railway company was given permission to demolish Trinity College Church on the condition that it would pay for the building of a new church of a similar style elsewhere. It was later determined, however, that it would be cheaper for the local council to rebuild the church using the old materials, which were purchased from the railway company at the cost of £475 and removed and numbered under auspices of architect David Bryce. The intention was to rebuild the church at a site on the south-western base of Calton Hill.

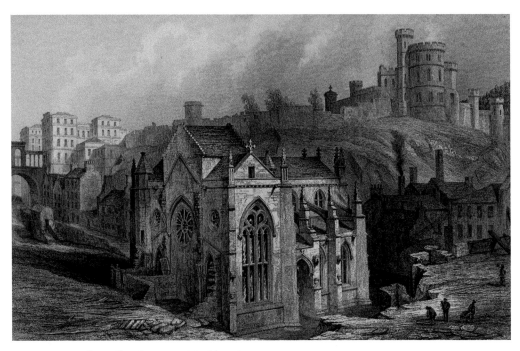

Trinity College Church in its original location.

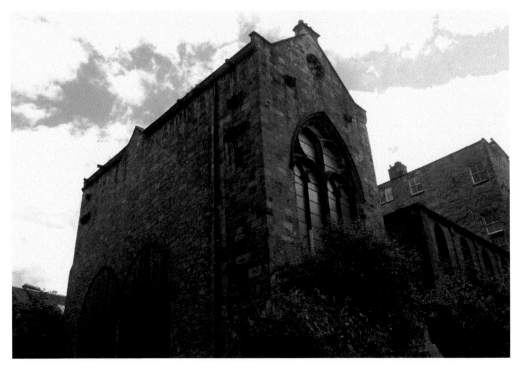

Trinity Apse.

Years of delay followed during which the council seemed reluctant to spend the money to rebuild the church. The Calton Hill site was ultimately declared unsuitable and it was not until 1870 that a new site at Chalmers' Close off Jeffrey Street was approved, by which time many of the stones had been pilfered. The architect John Lessels only reassembled the main part of the choir (though the resulting building has usually been known as Trinity Apse) and joined this to a new structure. The building finally opened in October 1877. The additional church building was demolished in 1964, leaving only the rebuilt section hidden away in the close. It was used as a Brass Rubbing Centre for many years and later for a variety of functions.

There is one remaining item of note from the original Trinity College Church which can be seen in Edinburgh. The altarpiece dating from the 1470s by Hugo van der Goes, and known as the Trinity Panels, is on display at National Gallery of Scotland. Commissioned by Edward Bonkil, the first Provost of the church, the panels, which include images of King James III and his queen, Margaret of Denmark, as well as St Andrew and St George, are thought to have been once part of a triptych, though the central panel was probably destroyed at the time of the Reformation.

47. TRON KIRK, 122 HIGH ST, EH1 1SG

The Tron Kirk or 'Christ's Kirk at the Tron' was designed by John Mylne, Royal Master Mason, and constructed between 1636 and 1647. The kirk gets its name from the salt tron, a public weighing beam which was once located nearby. It was commissioned by Charles I to accommodate a congregation which had previously met at St Giles' but which had been displaced when he made that church a cathedral in 1633. The Tron Kirk was consecrated in 1641. Above the door is the inscription: 'AEDEM HANC CHRISTO ET ECCLESIAE SACRARUNT CIVES EDINBURGENI. ANNO MDCXLI.' (This building the Citizens of Edinburgh have consecrated to Christ and His Church. In the year 1641.)

When Prince Charles Edward Stuart (Bonnie Prince Charlie) returned to Edinburgh in 1745 in triumph following the Battle of Prestonpans, he let it be known that church ministers should carry on as usual on the following Sunday but that in the prayers for the royal family, no names should be specified (thus sidestepping the question as to who was the rightful King – George III or Charles's father 'The Old Pretender'). Most of the regular clergy had made themselves absent. Revd Neil McVicar of St Cuthbert's, though, was to preach at the Tron. Revd Dugald Butler recounts what happened in *The Tron Kirk of Edinburgh* (1906):

> The church was filled with a great congregation, among whom he recognised many Jacobites, as well as some Highland soldiers, attracted by the report of his intentions, and the reputation he bore for courageous character. He prayed as usual for King George by name, and then added — 'and as for this young man who has come among us seeking an earthly crown, we beseech Thee, that he may obtain what is far better, a heavenly one!' When this was reported to Prince Charles, he is said to have laughed, and expressed himself highly pleased at the courage and charity of the minister.

There was a major reconstruction between 1785–87 during which part of the church was removed to make room for the construction of Hunter Square and South Bridge. In 1824, the Great Fire of Edinburgh destroyed the wooden church spire, which had been added in 1671. It was rebuilt in stone in 1828.

In 1934, a proposal was brought before the council that the Tron be demolished to ease the flow of traffic but fortunately this was not adopted and worship continued there until 1952. The Tron then came into the ownership of the council, while the congregation moved to Moredun in South Edinburgh to serve the new housing being built there. The church at Moredun retains 'Tron' in its name today.

Visitors from all over the world come to Edinburgh at the turn of each year to celebrate 'Edinburgh's Hogmany' in Princes Street, some no doubt believing that this is a location where the New Year has been celebrated for centuries but, in fact, this only dates back to 1993. The traditional place to celebrate was outside the Tron, no doubt because it was the place in the Old Town with the most prominent public clock.

The Tron Kirk has for many years been an empty shell with all its church furnishings removed, though some stained glass remains. Excavations in the building uncovered the remains of Marlin's Wynd, a sixteenth street, and the foundations of the buildings on either side of it. In May 2021, the City of Edinburgh Council and the Scottish Historic Buildings Trust (SHBT) announced plans to restore the building and secure its future.

The Tron Kirk.

SELECT BIBLIOGRAPHY

Bryce, William Moir - *The Black Friars of Edinburgh* (1911)

Carrlin, Norah, *The Devil in a Midlothian Village* Corstorphine Trust (2021)

Farmer, David, *Oxford Dictionary of Saints* Oxford, University Press (1997)

Gifford, John (et al), *The Buildings of Scotland: Edinburgh*, Penguin Books (1991)

Gray, W. Forbes, *Historic Churches of Edinburgh*, The Moray Press (1940)

Scotland's Churches Scheme, *1000 Churches to Visit in Scotland*, NMS Enterprises Limited (2005)

Scotland's Churches Scheme, *Sacred Edinburgh and Midlothian (Sacred Places)*, Saint Andrew Press (2009)

I would also like to acknowledge the work of the many anonymous authors who have compiled church histories in print and online.

Acknowledgements

All of the modern photographs were taken by me and the older illustrations are from my own collection.

Thanks to Revd Neil Gardner, Imogen Gibson, Louise Madeley, David Haggarty, Adam Cumming, Lesley Cumming, Revd Moira McDonald, Ellen McFadzen, Fr Adrian Porter SJ, Fr Dermot Morrin OP, Connor MacFadyen, Justin Nash, Alex Bewick, Revd Rosie Addis, Stephen Preston, Revd Dr Marion Chatterley, Fr Martin Robson, Sr Miriam Fidelis Reed RSM, Yvonne King and Revd Iain May.

Thanks too to anyone else who assisted that I may have forgotten or never known by name.

Readers may be interested in the work of Scotland's Churches Trust. Their website is WWW.Scotlandschurches trust.org.uk.